ESQUISSES DÉCORATIVES

PAR

René Binet

Architecte

Préface de GUSTAVE GEFFROY

PARIS

LIBRAIRIE CENTRALE DES BEAUX-ARTS

13, RUE LAFAYETTE, 13

[Original title page]

DECORATIVE SKETCHES

Architecture and Design Influenced by Nature
in Early 20th-Century Paris

René Binet

DOVER PUBLICATIONS, INC.
Mineola, New York

To

GUSTAVE GEFFROY

His grateful friend,

R. Binet

Bibliographical Note

This Dover edition, first published in 2017, is an unabridged republication of sixty plates from *Esquisses Décoratives*, originally published by Librairie Centrale des Beaux-Arts, Paris, ca. 1902. The original preface by Gustave Geffroy has been newly translated from the French by Diane Goullard, www.FrenchAndEnglish.com.

Library of Congress Cataloging-in-Publication Data

Names: Binet, René, 1866–1911, creator. | Geffroy, Gustave, 1855–1926,
 writer of preface.
Title: Decorative sketches : architecture and design influenced by nature in
 early 20th-century Paris / Rene Binet.
Description: Mineola, New York : Dover Publications, 2017. | "This Dover
 edition, first published in 2017, is an unabridged republication of sixty
 plates from Esquisses Décoratives, originally published by Librairie
 Centrale des Beaux-Arts, Paris, ca. 1902. The original preface by Gustave
 Geffroy has been newly translated from the French by Diane Goullard."
Identifiers: LCCN 2017022952| ISBN 9780486816685 (paperback) | ISBN 0486816680
Subjects: LCSH: Binet, René, 1866–1911—Themes, motives. | Decoration and
 ornament—France—Paris—Art nouveau. | BISAC: ARCHITECTURE / Decoration &
 Ornament. | ART / European.
Classification: LCC NK1449.Z9 B562 2017 | DDC 745.092—dc23
LC record available at https://lccn.loc.gov/2017022952

Manufactured in the United States by LSC Communications
81668001 2017
www.doverpublications.com

PREFACE

But if they can't understand that parts that are so small that they are unnoticeable can be as divided as the firmament, then there is no better way than to have them look through binoculars that enlarge that delicate speck to an enormous mass. There, they will easily understand that through the medium of another piece of glass, more artistically tailored, one can enlarge it to the point of emulating that very firmament, the vastness of which they admire. These objects now seem to them very easily partitionable, they may remember that nature is infinitely greater than art.

PASCAL: THOUGHTS (*Reflections Upon Geometry In General*)

. . . There is such an insect that by day or by night, viewed through the naked eye or under a microscope, would present no interest. But if, with the aid of a scalpel, you took the time, patiently, delicately, to lift from under the thick scaly wings the layers that form it, you would often find some most unexpected designs made of sinuous curves, twig branchlets, angular streaking figures, even hieroglyphics, reminiscent of the alphabet of certain Oriental languages.

. . . Truly, what is there that is similar or close to, in art? How tired it seems, so languid. How it needs to return to the living source! Habitually, instead of going directly to Nature, to the inexhaustible fountain of beauty and invention, arts have appealed to scholarly knowledge, to the arts of yesteryear, to the past of man.

. . . Our intelligent Paris merchants, who regrettably followed the paths that large producers imposed upon them, may one day break away from the powerful and rich. Some will have enough of it and, turning their backs on the scribes of old rubbish, they will inquire of Nature itself, the great collections of insects, the greenhouses of the Garden of Plants.

MICHELET: THE INSECT (*Renovation of our Arts through the Study of Insects, Ch. VII*)

The architect of the main entrance door [Ed.:"La Porte Monumental Paris," designed by architect René Binet, who incorporated illustrations from Ernst Haeckel's work *Art Forms in Nature*] of the Paris Exposition [Ed.: The *Exposition Universelle de 1900,* an international exhibition of new technology and cultural innovations, such as Art Nouveau], René Binet, is an artist who has an accurate sense of the general evolution of human endeavor. Therefore, he is not publishing this collection intending, overtly or covertly, that it is going to revolutionize the arts of furnishings, bring an expected epiphany, create a buzz, to use a consecrated expression, however irritating and unfit. Fortunately for him, he didn't invent the Binet style. He knows only too well that such a personal fantasy, one that would not pretend to be connected to what preceded it, would run the risk of falling flat. The author's objective is a lot simpler, and completely legitimate. Going through the trouble of carrying on his objective, the effort is necessarily going to be held back, categorized, and used, for the simple reason that it encompasses a great deal of necessary work and that it brings to its performance a spirit of unity and method.

Far from wanting to create a style, René Binet, relying on a process closely connected to careful and unassuming data in an experimental spirit, returns, in a way where ingenious invention and learned ingenuousness can be appreciated, to the origin of all styles, to the unchanging principles, those that are absolute and infinitely varied and complex, that determine the essential forms and their many derivations.

René Binet became aware that there is a way of escaping from the obsession with all the decorative forms we have inherited in the course of centuries, with all the trials and all the successes that make up today's code of tradition. This means to resort to the large laboratory of Nature, one that is always moving, always producing, never standing still for one instant, having not a single moment where it stops or hesitates. Therein lies the tried-and-true secret of all creation, of all transformation.

No doubt, others have asked its secret of nature. What am I saying? Others! All may not have obtained it, but all have asked, even those who claim to consider it of secondary importance and who substitute it for the genius of their theories. But it is a different matter altogether to peer into art or to question nature. An artist does not need theories to supplement nature, it is enough to want to translate it: inevitably, the artist's personality appears, his or her perspective, the way he or she sees, experiences, or understands, seeps through. He confesses his or her intelligence, his emotions, he creates the image residing in his mind, from which he creates his perception of the world. But, while he is thus manifesting a personal creation, he is conceiving a template that others, who don't have his sensitivity and clairvoyance, will merely imitate. They will imitate his discovery while distorting it, and nature will be sieved through the art, losing its native force, its freshness, its vigor, its original grace. This explains one reason why, in the arts applied to everyday subjects—as for other arts—the fading away, the falling from fashion in all forms and all ornamentation that once had their youth and their blossoming. Formulas wilt, become wrinkled, are abraded, die, over the course of a long period during which they decompose, become more complex, and show the pointless, puerile, sad game of their slow demise, in lieu of subtlety and refinement.

This means that every time the sap dries up, every time the sense of things natural becomes scarcer and scarcer, one has to exert a sudden burst of the will and return to the inexhaustible source.

It is into this exertion of a burst of the will that René Binet has dipped. He has traveled to the invisible world, to the infinity of the forms revealed by the microscope. He has studied with passionate focus the general characteristics of these forms and the flow of their derivatives. He has learned the perpetual renewal of life that is hidden in the depths of the ocean, all this universe in constant movement, where separate forms constantly emerge from the transitory mixture of mineral life, vegetable life, animal life. In the sixteenth lesson of his *History of the Creation of Organized Beings*, does not Haeckel say the following:

"We see perfectly that beings are divided into vegetable and animal forms, and it doesn't come to our mind to think that these beings might originate from one common source. Yet, it does, or, at least, it seems to, since as you climb up the ladder of original life, you arrive, beyond ferns and mollusks, at a group, called the *protists*, of which most of the representatives are of so small a volume, that they are, more or less, invisible to the naked eye. The drama of their lives is so singularly a mixture of animal and vegetable properties, that the existence of their groups has not been classified in any kingdom.

The conflicting information that has arisen on their existence does not result from our lack of knowledge on the subject of protists, but rather stems from their unicellular nature."

We see how a contemporary artist, such as René Binet, who turned toward a scientific culture, foreseeing that an increasingly greater knowledge of the world

could reveal countless forms, was led to apply his works to natural history, which seemed so different from his architectural work. Such a simple, legitimate connection. To start with, why wouldn't he have felt passionate about Nature, in its immense labor; expanding on his experiences, attempting to succeed, by creating an incalculable variety of drawings based on the protists, which separate themselves into two kingdoms: one attached to the soil, growing from the ground where it was born, a type that cannot move through its own will: the vegetable organism; the other, whereby its organisms have the faculty of being able to move from place to place: the animal organism. This classification having been established, Nature reaches deep into its blueprint to sketch them in one direction or another, but this

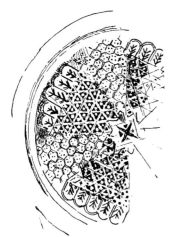

Fig. 1.

evolution is slow, spanning centuries, from which stems the resemblance between the melethallia, the radiolara, and certain sponges.

This is our artist, one who follows the learned professor at the University of Iéna, who was preceded in this study by Ehrenberg and Orbigny. He examined the larger categories of the intermediary kingdom of the protists: first, the Moneras; second, the Bacillus; third, the Infusoria; fourth, the Rhizopoda. He learned that the Bacillus gave birth to the Diatoms, the Rhyzopoda gave birth to the Thalamophora and to the Radiolaria. He looked at the Diatoms and found most interesting these small microscopic cells, enclosed within a soft cell wall of silica, which produces the most elegant and diversified forms.

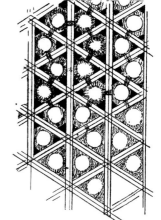

Fig. 1 a. — Carrelage.

In some cases, the cross-section of those infinitely small cells is sometimes triangular, in some cases hexagonal, square, or octagonal, or even circular, divided into ten segments, radially striated by crosscutting in a geometric diamond shape, and studded with small crosses.

Despite the infinitesimal smallness of these Diatoms, the orderly organization of their divisions is of the utmost perfection, while at the same time their opposing geometric shapes are the most varied. If, for example, a Diatom like the one in Figure 1 has many tiny geometric figures, there exists a perfect harmony between them: for example, a segment composed of equilateral triangles is surrounded by hexagons and fringed by spicules forming a 60° angle with its axis, there is no doubt that harmony is present between these polygonal figures of 60° and 120°.

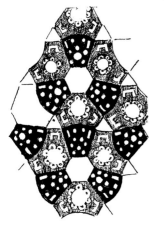

Fig. 2 a. — Carrelage.

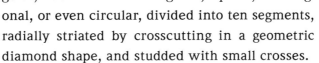

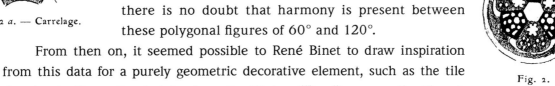

Fig. 2.

From then on, it seemed possible to René Binet to draw inspiration from this data for a purely geometric decorative element, such as the tile drawing in Figure 1a, deriving from the Diatom (Fig. 1), or even the tile pattern (Fig. 2a), where the main element is derived from the Diatom (Fig. 2), divided into six segments: three black dots spangled with six white dots, encircling a sort of larger rose, and three gray dots punctuated by even finer dots, studded with black dots. This opposition naturally created two tones in the tile that became red and black, for example.

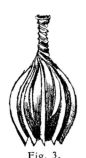

Fig. 3.

Do you feel an increasing interest for the artist as he moves from this class of Diatoms to a superior, more complex, more developed class than the Thalamophora, for example? The Diatoms are almost nothing but surfaces, while the Thalamophora clearly have volume.

Their limestone shell is cleverly divided into a large number of chambers arranged in concentric circles, or ringed spirals, and often are distributed in tiered layers like the loges of a vast amphitheater. Such is the Thalamophora (Fig. 3), which looks like a bottle, wrapped around the sharp edges of spires that grow out

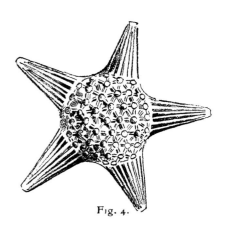

Fig. 4.

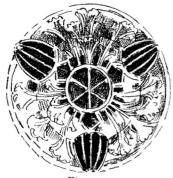

Fig. 4 a.

of the neck and protrude over the stomach. Or else (Fig. 4), we have a sphere, encircled by a lattice pattern of equilateral triangles where each angle is marked by a finely chiseled ball, surrounded by five cone-shaped, dull spikes, enveloped by equal ridges, radiating at the apex, their form wildly contrasting with the center, and the concept suggesting a rosette (Fig. 4a).

Thus, we take those infinitely small things one by one, and seek the reason for their beauty, their life. With the Diatoms, we will always find that the reason for their beauty and life is an equilibrium, superior to that of the art of humans, however perfect that may be. Pure reason, or absolute necessity, governs. Function dictates the organs; the fragile existence of an animal requires a shell made of spirals, ducts, delicately laced windows, and such residence, invisible to our eyes, turns into a palace, with mazes, galleries, doors. Palaces of that nature are innumerable, or they are suspended in the depths of the seas.

But we need to continue, displaying the work of the artist, by the drawings he makes of these subjects, by the applications they evoke, by the evolution of forms and the decorations they model for him.

Thanks to him, I saw the extraordinary Radiolaria, the most perfect class of the Rhyzopoda group.

Owing to the learned professor M. Lucien Cayeux, of the National Agronomic Institute, we were able to admire the most perfect specimen of the group under a microscope.

It is especially after following a beautiful English expedition aboard the *Challenger*, led by zoologist Wyville Thomson, that the Radiolaria were discovered and studied. And it is thanks to Professor Haeckel's research on these animals, almost unknown up to that day, that we can glimpse the infinite richness of the protist kingdom. However, I must reference the forty-six volumes published on the *Challenger*'s expedition, in which the plates are explained strictly through a naturalist's viewpoint. No scholar believed it necessary to sidestep his field of expertise to show the mathematical angle and the static of its forms. Likewise, no artist had thought of entering this living world to be mindful of the force of construction that supports it, or the graceful ornamentation that beautifies it.

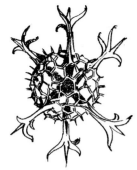

Fig. 5.

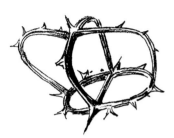

Fig. 7.

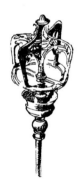

Fig. 7 a.
Bijou

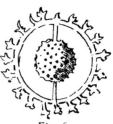

Fig. 6.

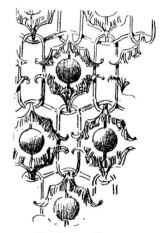

Fig. 6 a. — Treillis.

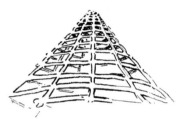

Fig. 8.

Fig. 8 a. — Bouton électrique.

This man did. He presents to us the fruits of his study.

He recognized that the organizing principle of the Radiolaria was generally a sphere bristling with extremely fine needles. However, there are many variables associated with this primordial form!

Here we have a lattice globe whose every mesh is a hexagon with six prods that are like spears diverging in the meridian plan (Fig. 5).

There we have, around the lattice globe, an equatorial ring, resembling the ring of the planet Saturn (Fig. 6). Such a simple, quasi-metallic form can produce a trellis if several similar elements are combined (Fig. 6a).

Then, there is this other form (Fig. 7), almost as simple, and as perfect: three siliceous hoops, situated in perpendicular placement among themselves, connected to one another, creating a sort of crown of thorns. It is a form that is dimensionally stable, because each arc contributes to the rigidity of the whole, invisible skeleton, dust atom, that includes the principle of the large circular base vault as well as the fine, chiseled gold pinhead (Fig. 7a).

This other Radiolaria (Fig. 8), no less simple, yet no less strange, has the form of a pyramid with nine panes, where the spines are joined together by horizontal trabeculae, ending in nine-sided polygons, where the interspace and the surface decrease as they get nearer and nearer to the peak.

Sometimes, the angle at the peak of this pyramid is very sharp, sometimes, it is very open: an artist could conceive a lattice positioned on a slab, having a leafage underneath it to lessen the lack of rigidity of the whole (Fig. 8a). The veins, as previously, could form the metallic skeleton of a gigantic shelter. Similarly, from Figure 9, which could easily fit in a semi-circle, a spandrel could have been born (Fig. 9a).

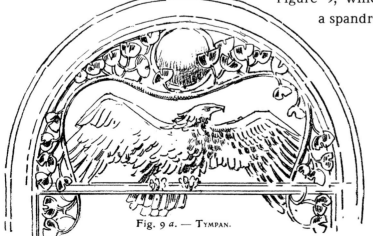

Fig. 9 a. — Tympan.

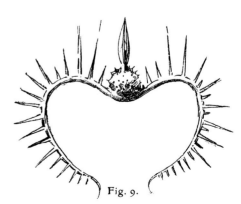

Fig. 9.

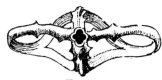

Fig. 10.

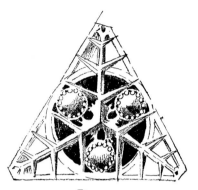

Fig. 11 a.

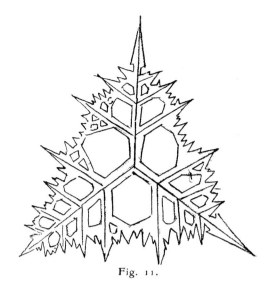

Fig. 11.

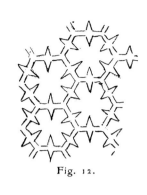

Fig. 12.

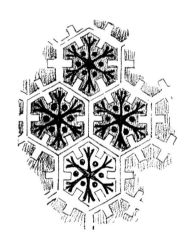

Fig. 12 a.

Likewise, the Radiolaria (Fig. 10), gives the appearance of a ring having a matching bezel, with no need for further graphic illustration.

Other categories, similar to blades or spearheads, radiate in accordance with given angles, and trigger the mind to think that a ratio might be sought out and established between these siliceous and crystallized skeletons, although that may not agree with actual science. Doesn't Figure 11 make you think of lace, having an even and capricious crystal pattern? Doesn't such a geometric formation remind you of a triangular envelope, a symmetrical component serving to draw a fastener where silver or gold would encase emeralds or amethysts (Fig. 11a)?

Can we not also imagine that the very particular hexagonal network of Figure 12 can be the starting point of the layout (Fig. 12a)?

In Figure 13, the spicules are translated by a surface covered with radiating apertures where the three branches have taken the simpler tapered form, from which a precious metal fastener can be imagined, enhanced by enamels (Fig. 13a).

However, despite an interest in novelty and variety, it is impossible to show here all the individual forms of the Radiolaria. The *Challenger*'s voyage added a thousand additional new species to those already known. And here is one more, in addition, that René Binet claimed with enthusiasm was the most beautiful of all, the *clathrocanium reginae*, which sums up in itself the richness and the logic of this mysterious family (Fig. 14).

As can be seen, it shows a perfect harmony of curves, an unparalleled lightness, a fullness at the points of

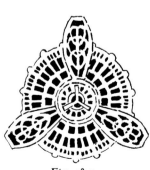

Fig. 13.

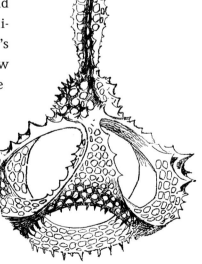

Fig. 13 a.

Fig. 14.

x

Fig. 14 a.

stress, a constriction at the opposing points, with a wonderful crowning of four pointed tips grouped like a cross. This forms a tiara, a diadem if you will (Fig. 14a). It is also the primordial form of the gigantic door of the Exposition, which had, one cannot deny, not only the charm of its luminous coloring, but also the logic of elegance in its solid construction.

Fig. 15.

This leads the artist to examine the resistance of the arches and walls of the Radiolaria from a purely mechanical perspective. Figure 15, he tells me, formed in a semi-spherical shape, has three spicules at the base and one at the peak. Its resistance to shock is due to the three perforated wings that straddle the dome. This schema and Figure 15a show very well how the spicules are completely

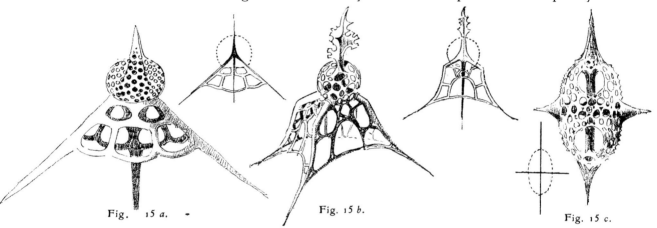

Fig. 15 a. Fig. 15 b. Fig. 15 c.

joined by a perforated sphere where the center is located at the meeting point of the four spicules. The hollow sphere is as resistant as if it were solid and secures the four ribs incorporated into its volume. The same observation is applicable to Figure 15b, having an inherently stable volume due to the place-ment of the mesh between the spicules: in Figure 15c, in which the two axis cut in the same plane of uneven length, and, as it were, are locked in an openwork ellipsoid. Figure 15d, more co-herent, shows three axis crossing like the symmetrical axis of a cube.

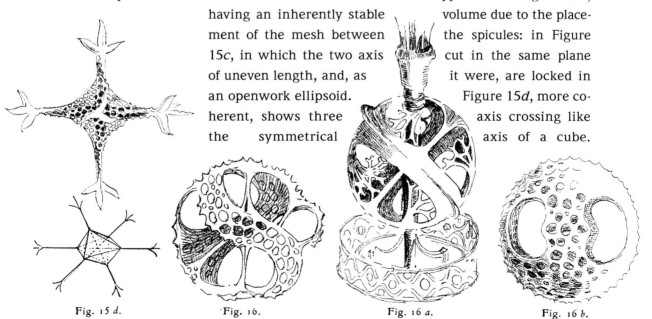

Fig. 15 d. Fig. 16. Fig. 16 a. Fig. 16 b.

Let's examine the same principle with an orb: Figure 16 will be the departure figure for 16a, which is the baseplate of a spike that can act as a pellet, in Figure 16b, and is

not laced as delicately, but offers more resistance.

Figure 17 shows the mastery with which some Radiolaria are constructed. Their varied trellis interconnecting with meshes tighten up more and more toward the point of intersection where the individual mainly resides. Figure 18 looks like a sort of ornamental openwork design, having a long neck, with ten wings that prevent the neck from bending if a movement must be exerted between points f and f'.

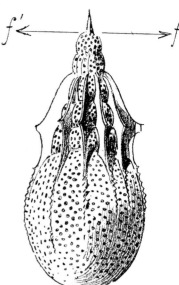

Fig. 17.

Fig. 18.

Continuing the study of both kingdoms, we arrive at the conclusion that such individuals, vegetable or animal, are very close in their structure to certain protist categories. In the Porifera category, the limestone sponges. Not as rich a form as the protists, they also present very diversified forms. A sponge of this type shows an array of limestone needles bathed in a soft substance, apparently disagreeable. Each needle displays a sort of harpoon at its extremities, with the function of retaining the soft matter. The series of spicules is remarkable.

Fig. 19 a.

The group of spicules (Fig. 19) might have served as the theme to form the weathervane (Fig. 19a), and to provide one of the lead crests on the RIDGEBOARD assembly illustration. The Porifera (Fig. 20) has led to the clay Ridgeboard assembly in Figure 20a. And this other, having such a geometric form (Fig. 21), provides of course the principle behind the Roses of the Rosette assembly. Figure 22 shows other rosettes with spokes ending in a harpoon form, very different from each other.

Fig. 19.

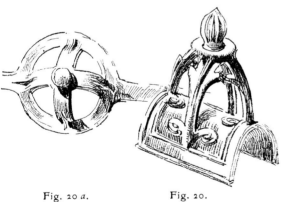

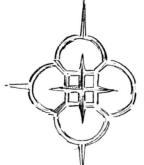

Fig. 20 a. Fig. 20.

Fig. 21.

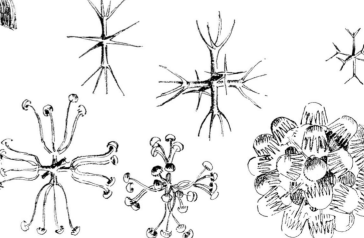

Fig. 22.

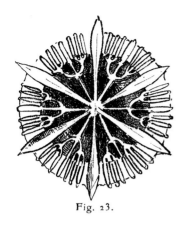

Fig. 23.

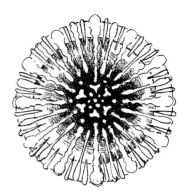

Fig. 24.

After the sponges come the corals. Each of the figures shows a unique set of rods. In some cases (Fig. 23), the significantly contrasting spokes determine the segments in which many seven-branch candlesticks can attach themselves: the main stem might start from the center, the illumination extends to the arc of the circumference. This form was applicable to an object that would be subdivided in three, such as the assembly plate of a chandelier (Illustration CHANDELIER.)

By comparison, in Figure 24, the small and large spokes converge to the center, where they become thin (Illustration ROSETTE.). Figure 25 comprises finely perforated circles, interconnected among themselves by very fine and regular mesh. The figure looks like a mosaic, having a bas relief of white marble (Illustration FENCE.)

Let's touch upon the Bryozoa, a very common, rich, and diverse class. Samplings have made it possible to rediscover large regions of it undersea. Orbigny tells us that paleontology demonstrates that "the Bryozoa have always, despite their being such tiny little individuals, played an important role in the zoological eras of our global history." They too present more or less uniform hexagons, most often perforated. The colonies often display a decorative motif of the most perfect kind.

Figure 26, for example, comparable to a Moorish carving, suggests a thousand applications of laced metal, a covering for flat surfaces, pillars, trellis, etc., as seen in Figures 26a and 26b, of the illustrations FENCES and TRELLIS. Figure 27 determines the main lines, the shadows, the lights of a marble fence (Illustration FENCE.)

Just as the surface of a colony of Bryozoa constitutes a harmonious ensemble, so does the ensemble shown on the cross-section present movements and groupings of a perfect logic. In Figure 28, the artist was able to draw inspiration and create metal cut-outs (Illustration DOOR). The arrangement of Figure 29 has provided the artist openwork patterns that can be

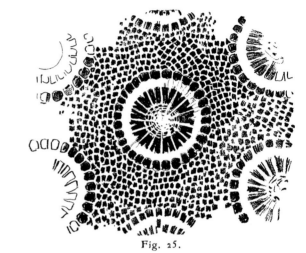

Fig. 25.

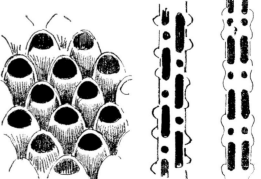

Fig. 26. Fig. 26 a.

Fig. 26 b.

Fig. 27. Fig. 28. Fig. 29.

Fig. 29 a.

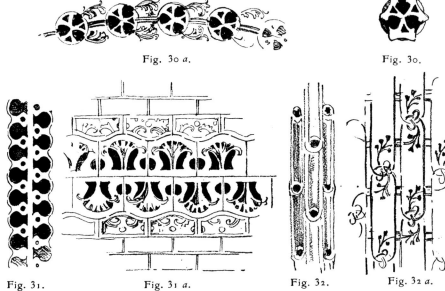

Fig. 30 a.

Fig. 30.

grouped on the circumference of a ring (29a). The simple cross-section of Figure 30 is arranged to form the mesh of a long chain-stitch (Fig. 30a). The cross-section of Figure 31, perhaps

Fig. 31.

Fig. 31 a.

Fig. 32.

Fig. 32 a.

more remarkable due to the way the cells alternate, suggests an interweaving of clay behind its arrangement (Fig. 31a). Figure 32 leads to the meshes on the trellis (Fig. 32a), and Figure 33 furnishes the meshes of Figure 33a, used in the Illustration TRELLIS. Figure 34a, generated by Figure 34, finds its application in the illustration WALLPA-

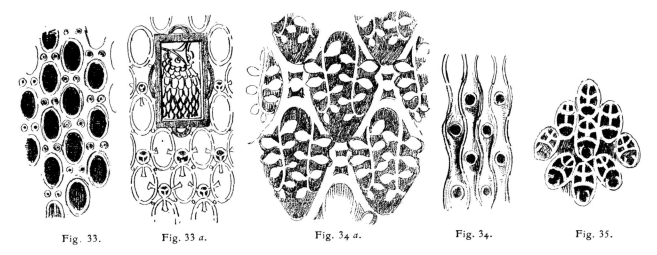

Fig. 33.

Fig. 33 a.

Fig. 34 a.

Fig. 34.

Fig. 35.

PER. Figure 35 leads to Figure 35a, found in the illustration SEAT. The same element, enclosed in a hexagon having four sides of equal length, is found in the illustration TILE. Figure 36, appearing more metallic, seems to call for repoussé or chiseling. It

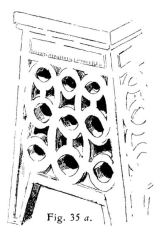

is definitely an element related to jewelry. Certain fragments of these Bryozoa can even present a ring on which we can easily conceive the presence of gemstones or enamels, at the peak of the serrations. Others can be translated in metal repoussé: we will find two simple embodiments, having no protuberance, that produce an object soft to the touch on a doorplate.

Fig. 35 a.

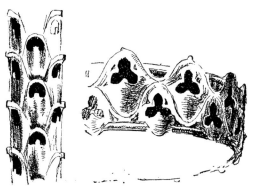

Fig. 36.

Fig. 36 a.

Other colonies are subject to triangular-shaped arrangement. Depending on the condition of the cells, they present a truly remarkable progression (Fig. 37), in complete agreement with the ornamental data that stipulates full designs at the base

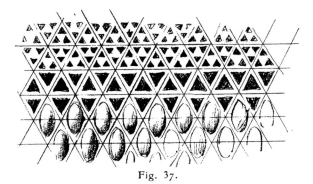

and lacier parts at the top. We will find one application of Figure 37 on the DOOR illustration, with the clay column.

Here is, also, another possibility of an application that applies to an extremely strange group, a group named the Echinoids.

The shell has a basic five-fold symmetry. Over time, each species has altered and become a small, flattened half-sphere, or an almost perfect ellipsoid. Apart from this

Fig. 37.

form, which is extremely resistant to external forces, the surface is sculpted with an art that is exceeded only by the richness and diversity of the most delicately carved Moorish bronzes or the shells of old Japanese armor. The shell of an Echinoid is a perfect geometric unit. The number five prevails everywhere: five long grooves along the irregular pentagonal plate. Between these large grooves are other assemblies of irregular pentagonal plates. Each of these shells is, by itself, a whole. In the center of the irregular pentagon that determines a shell, a raised semi-sphere juts out, acting as a hub for the long slender and chiseled spines that cause the shell to bristle.

Around this semi-sphere, a small "throat," and, concentrically, a series of protruding, perforated tubercles. This is the form used for the ornamentation of the Etruscan shield.

Between two shells that are joined side by side, another finds accommodation in a corner section (Fig. 38). This constitutes a rare amalgam reminiscent of ceramic coatings, whether uniform or in strips, that appear gently raised and give the enamel a small cavity that twinkles in the light (Fig. 38a, and the illustration ORNATE BRICK).

Fig. 38.

One can also notice the belt buckle of the illustration JEWEL, the carved nail of the illustration NAIL, and, when the sight of an Echinoid leads to greater subjects, one can perceive the decoration of a niche in marble having leaded or gold-studded inlays. (Illustration LEADED INLAY.)

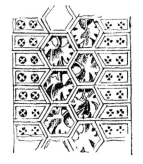

Fig. 38 a.

The central plate shows remarkable divisions, with ridges, joints, connecting points with the five large ridges or the overlapping interleaving. This plate is complete in itself, as Figure 39 can inspire a necklace (Illustration FASTENER) or the lattice-like plate of a doorknocker.

This review could continue endlessly. After the Echinoids, the Crinoids are a formation of the same order. The Crinoids have starry cross-sections. We can easily conceive how rich they are, when we see that a stalk of a Crinoid is a column often possessing a pentagonal cross-section. We could travel to the far reaches of this intermediate animal and vegetable universe, since diverse groups of algae are, says Haeckel, "so microscopically small that they could hold hundred

Fig. 39.

thousand pinheads." To mention just one example, plants such as thallophyte (mushrooms, lichen, and algae) are of a baffling uniformity, having a very wide originality of design combinations (Figs. 40, 41, 42). One of them, Figure 43, presents at first glance a great resemblance to the Echinoid of Figure 39. Yet the existing scientific divisions suppose them to be very far from each other. Think of what Goethe said, that "the organic species related by their form are really consanguineal, having a common ancestral form."

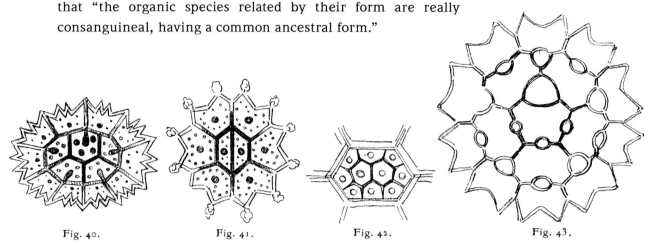

Fig. 40. Fig. 41. Fig. 42. Fig. 43.

There are rather numerous examples for those who would be interested by such studies. At this point, we can draw one conclusion.

The more we observe these figures, the more we notice that a mechanical law, a law that is vital, has mandated in every one of these volumes the suppression of any unnecessary material, leaving only the backbones and the surfaces that must bear the load, and adding, in some cases, only the elements necessary to ensure the rigidity of the whole. Only the absolute minimum. That is the master lesson.

Thus appears, in its hidden splendor, this minuscule, invisible world. When light is cast on it, when the microscope reveals it, this world explodes in a thousand whimsical images, rationally based, displaying the mystery of the outline, the charm of its spontaneity. Strange openwork cupolas, light decorative arches, all these trifles have such perfect proportions that they can lend themselves to any developments, reaching colossal proportions. There are building plans that could house humanity in the smallest atom of the animated mud that covers the bottom of the seas.

The genius of scholarship has discovered this. The pressing desire to "know" has led man toward this hidden unknown, has revealed to him that the system of the worlds has its origin in the infinity of nothingness. While Le Verrier is best known for predicting the existence of Uranus in the immense field of the known celestial bodies, Ehrenberg, and later, Haeckel, revealed through the Radiolaria something new that was harmonious and beautiful.

Thus, Renan's beliefs are verified in his work *The Future of Science*:

"Comparable anatomy draws many more results from the observation of inferior animals than from the observation of superior beings."

I have quoted an observation from Pascal and the prophecy of Michelet. The work of René Binet can still invoke Proudhon. In his book about the principle of art and social destiny, he writes:

"It is therefore Nature's work that the Artist furthers, by producing images in accordance with his ideas, according to what he wishes to communicate. In order for this sort of continuation to be in harmony with Nature, we have to seek to understand its secrets, so as not to go astray. And this cannot be done only for the arts of his profession, but he must look around him and take science into account . . .

The artist produces nothing out of nothingness, he simply grasps the ratio, analyzes figures, combines traits, reproduces them. That is what constitutes his creation.

Therefore, the more one observes, the more one discovers. Inspiration is directly proportional to observation. This is why we can honestly say that, in a true artist, inspiration never fails."

As to how such studies would specifically apply to the architecture and form of objects, it seems to me that they would be best justified by some examples. In essence, René Binet looks to the invisible world for what others search in wildlife. However, a flower, soft and pliable, is openly available for ornamentation, while this invisible world of rigid, exact, whole, and complete forms is ready for architecture. This is the point where science enables us to observe the evolution of the species, where it catches on the spot the matter that the artist, like a meek and modest pupil, is endeavoring to study and learn lessons from the emerging and burgeoning world of form and movement. It is the workbench where the artist is learning lines, and angles, and circles, ellipses, and stars, where all figures he traces with his pencil turn into an extraordinarily vibrant and alive geometry, where his imagination multiplies the results.

His personal contribution does not consist only in the choice of means and materials, although that would already constitute a major task, extremely useful. By a thoughtful process that seems simple now that its execution can be followed step by step, René Binet has not only created the means of reproducing architectural forms and the sculptural ornamentation of objects inspired by this invisible and precise life, he has also shown us, by focusing his ardent desire of comprehension and assimilation, how magically the very objects of his observation are already complete, ready to reproduce.

This is why, if a reason was needed, he can afford to share his crop generously, which is what he has been doing. Some will not see what he has endeavored to see. Some will be blind to it altogether, or they will see something else in it. The honor of the discovery is his. The honor of a certain performance, which will be his, belongs to him as well. His secret, for there will be a secret still kept, will be how he recognized all these forms, of disparate existence really, how what he saw could suggest the application of ideas such as electrical implementations, fasteners, rings, credenza, balconies, railings, woodwork, tiles, tents, interlacing, cantilevers, mantles, weathervanes, meshes, clocks, lanterns, chandeliers, mosaics, wallpapers, cane heads, rosettes, rugs, vases, etc., to name but a few of the subjects mentioned in this work, which is a large dictionary of customary and decorative forms. Better yet, René Binet saw, most often, in the same form, the principle behind many different objects, and one must believe, at this point, that he was correct, since everything he presents here appears constructed and logical.

Such is, to be brief, the substance of this collection. I have sufficiently indicated its origins, and I feel I do not need any further to indicate its documentation. It is not surprising therefore to discover some relationship with, perhaps elusive, conceptions, be they from India, China, Japan, Greece, Mexico, Mauritania, in the works of

the architect of the main entrance door of the Exposition. Such architecture resembles an old memory of a memory, yet it isn't that either—it is but the resurgence of principles, the return to the same study.

This demonstrates the high level of interest of the work that follows. It is fitting to add that all the objects assembled here are not shown only in the linear form habitually used by architects, but in their entire, massive form, with their surfaces presenting light and darkness. The presentation is clear, the explanations as mindful and comprehensive as possible. The result to hope for, what must necessarily derive from such research, is that René Binet gives us what would ensue from precepts and facts—that he continues to create, with an expert hand, the objects that his artistic imagination has conceived, and which he reveals to us here as realizable and harmonious.

GUSTAVE GEFFROY

LIST OF ILLUSTRATIONS

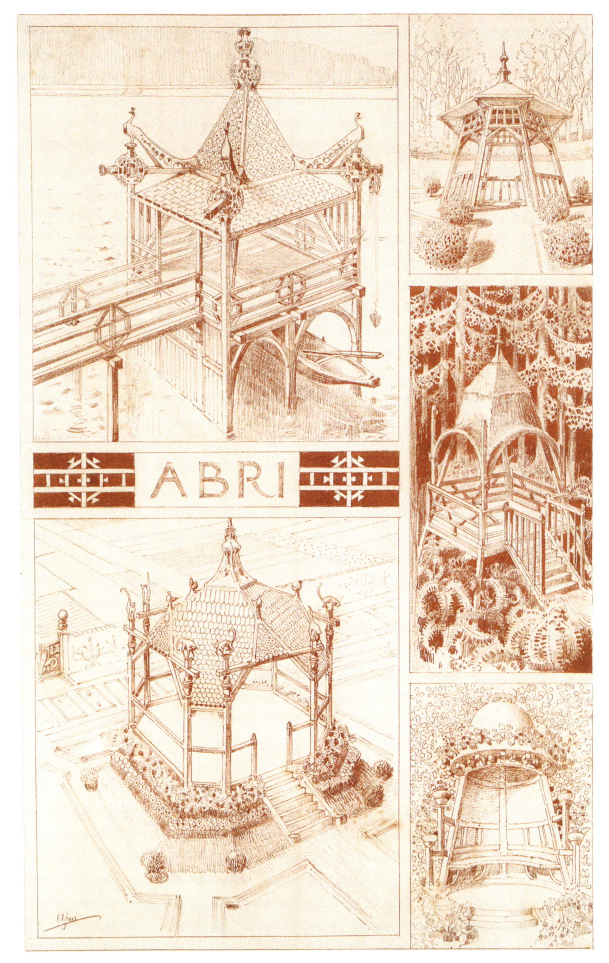

ABRI

PLATE 1.

AGRAFE

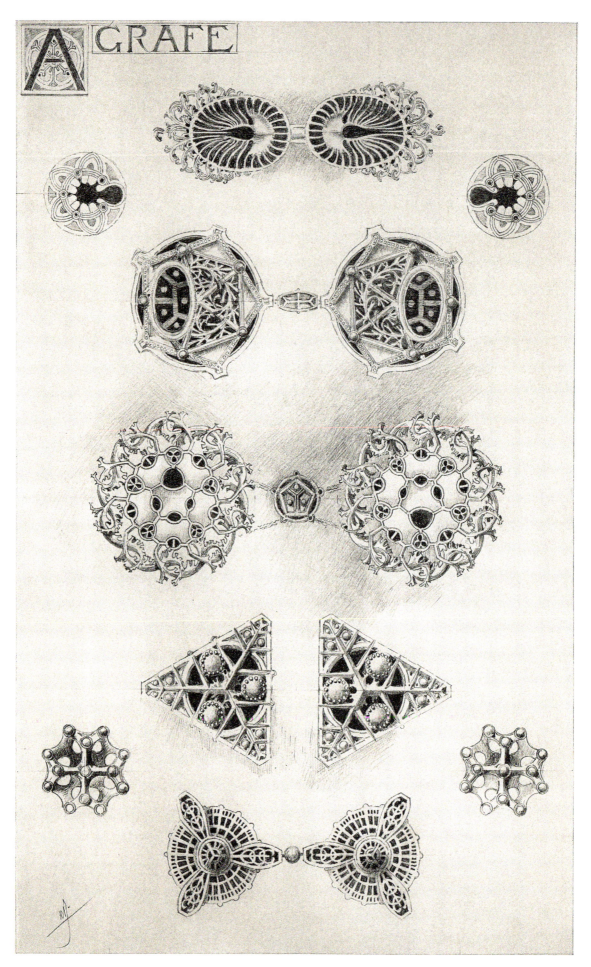

PLATE 2.

ANNEAU

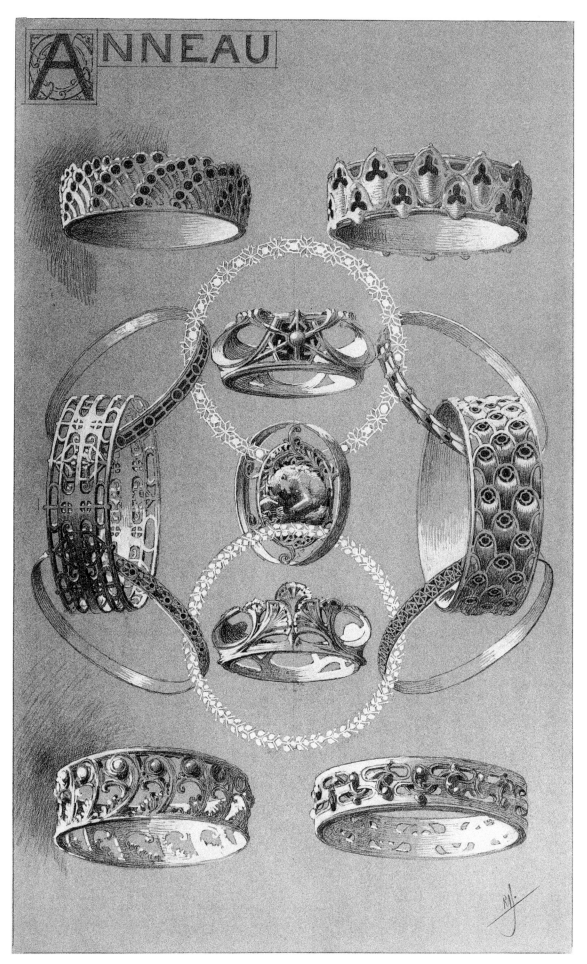

PLATE 3.

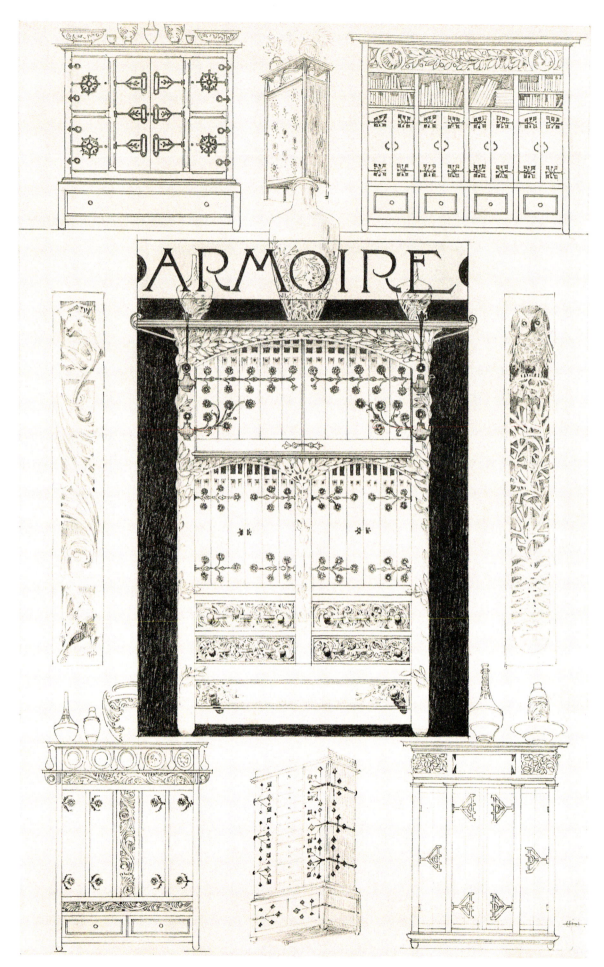

ARMOIRE

PLATE 4.

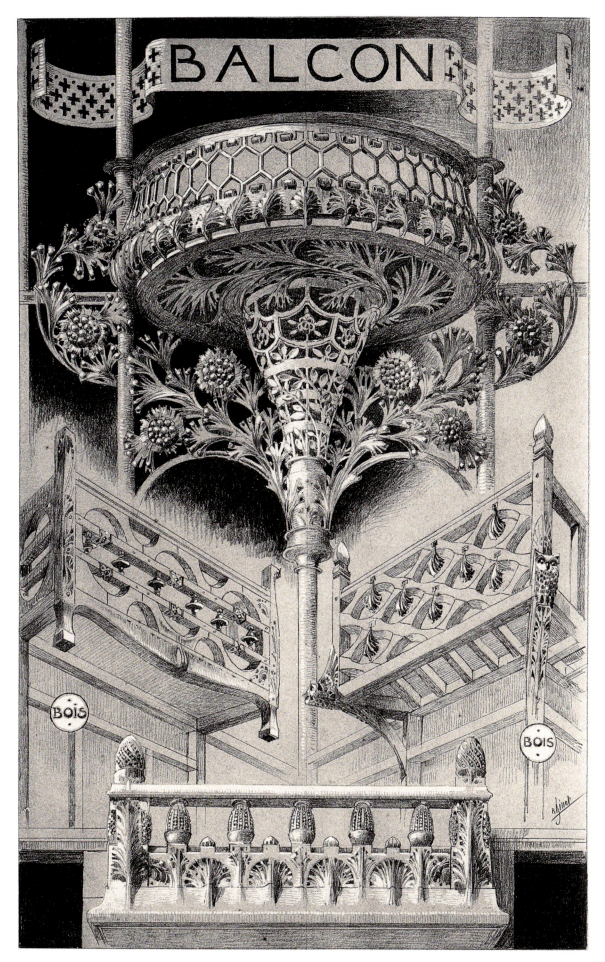

PLATE **5**.

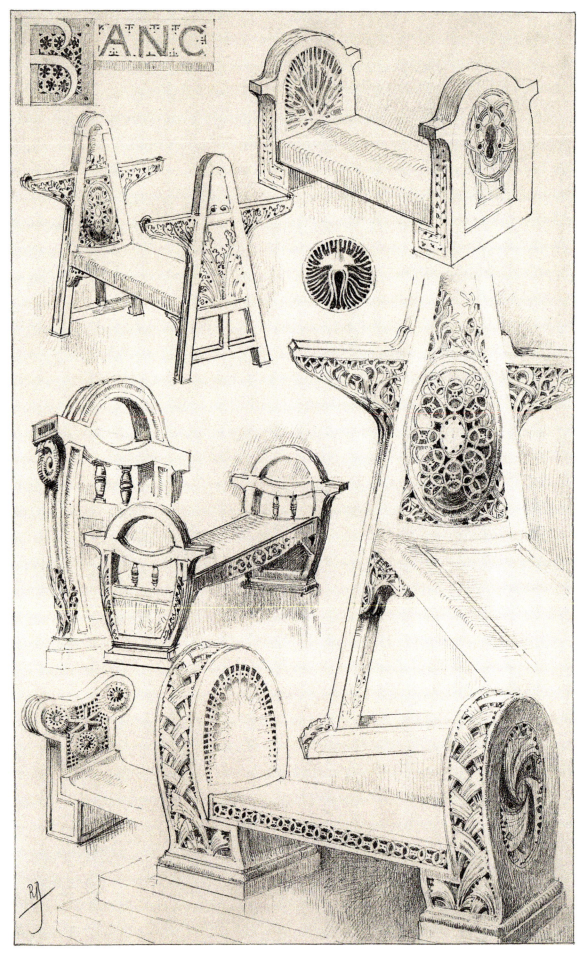

PLATE 6.

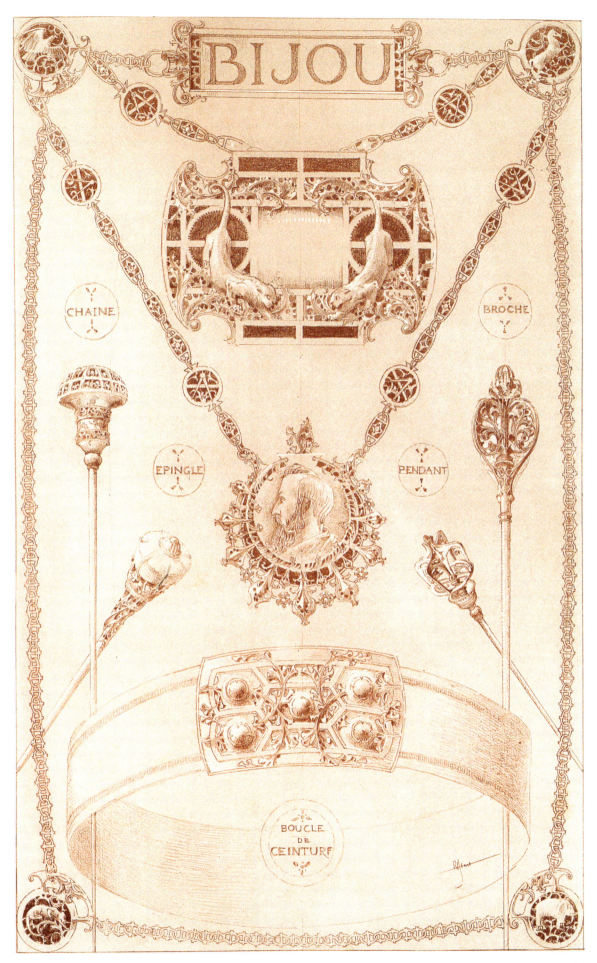

CHAINE — BROCHE — EPINGLE — PENDANT — BOUCLE DE CEINTURE

PLATE 7.

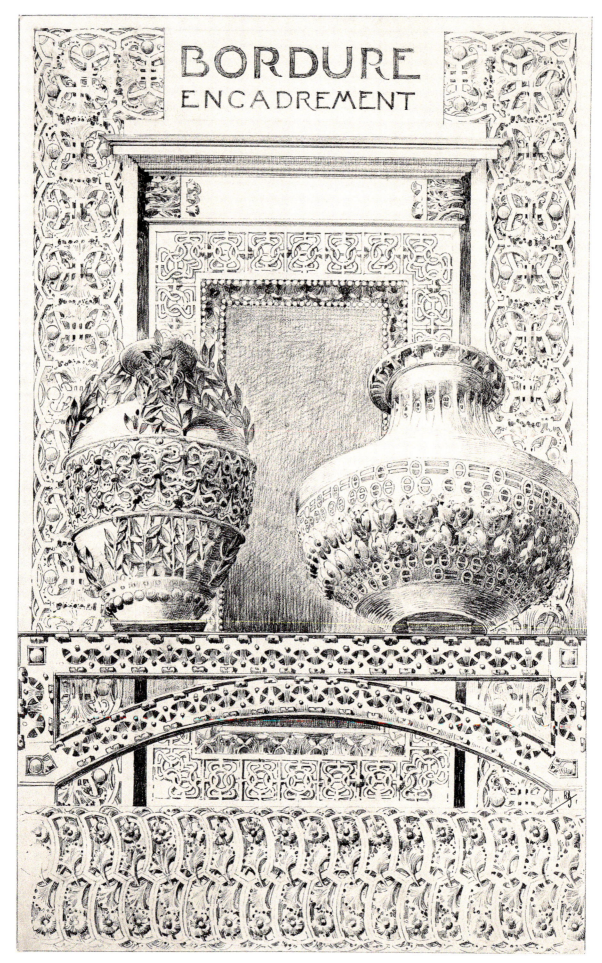

BORDURE
ENCADREMENT

Plate 8.

BOUTON ELECTRIQUE

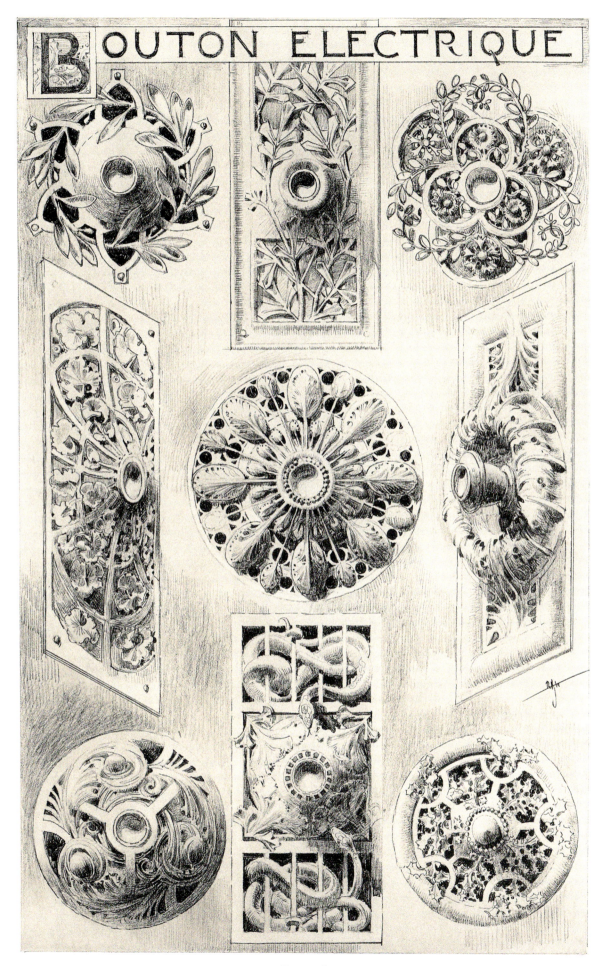

PLATE 9.

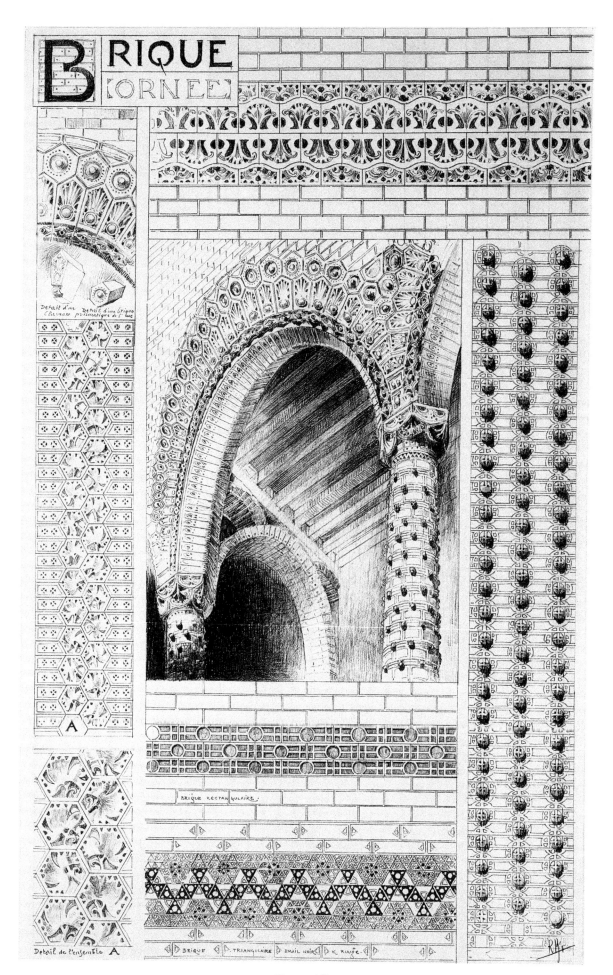

BRIQUE ORNÉE

Detail d'un Detail d'une brique
Claveau prismatique de 1 arc

A

Detail de l'ensemble A

BRIQUE RECTANGULAIRE

BRIQUE TRIANGULAIRE EMAIL NOIR & ROUGE.

PLATE 10.

CARRELAGE

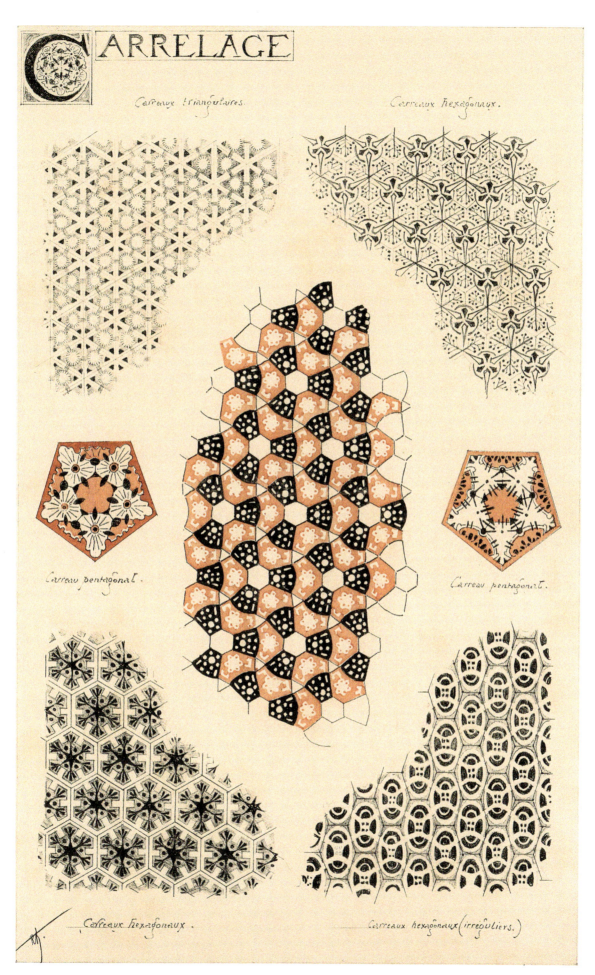

Carreaux triangulaires.

Carreaux hexagonaux.

Carreau pentagonal.

Carreau pentagonal.

Carreaux hexagonaux.

Carreaux hexagonaux (irréguliers.)

PLATE 11.

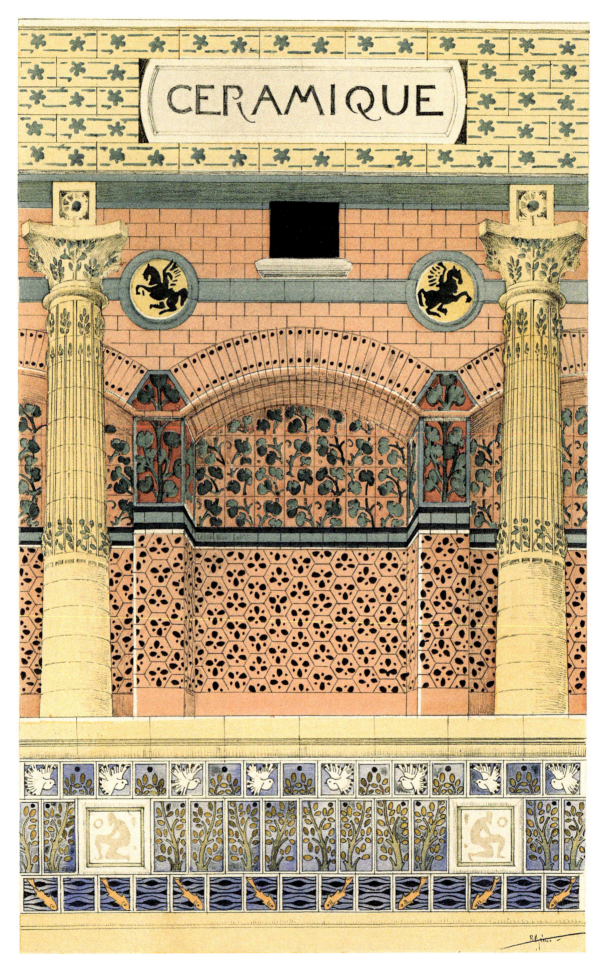

PLATE 12.

CHAPITEAU

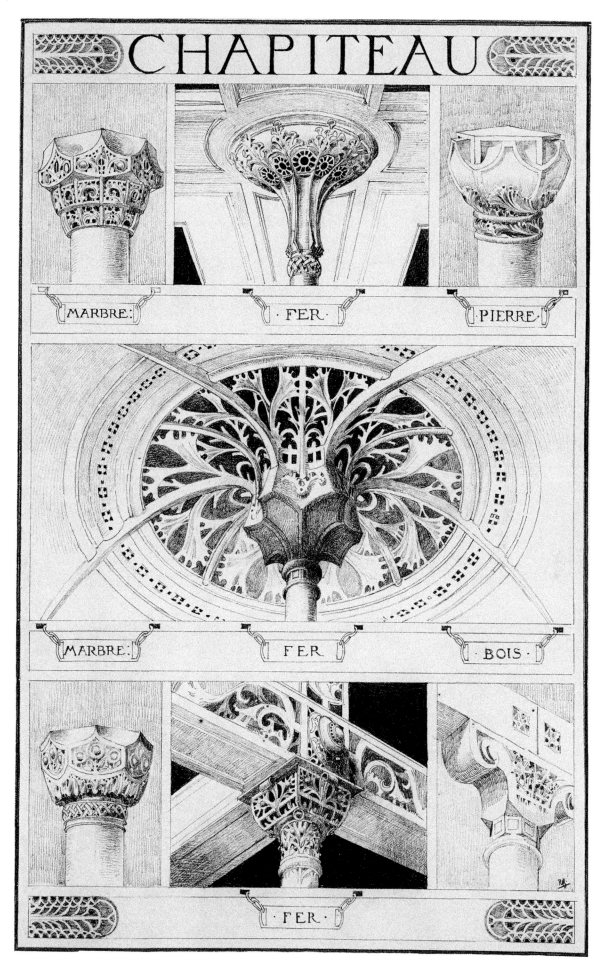

MARBRE: ·FER· ·PIERRE·

MARBRE: FER ·BOIS·

·FER·

PLATE 13.

CLEF

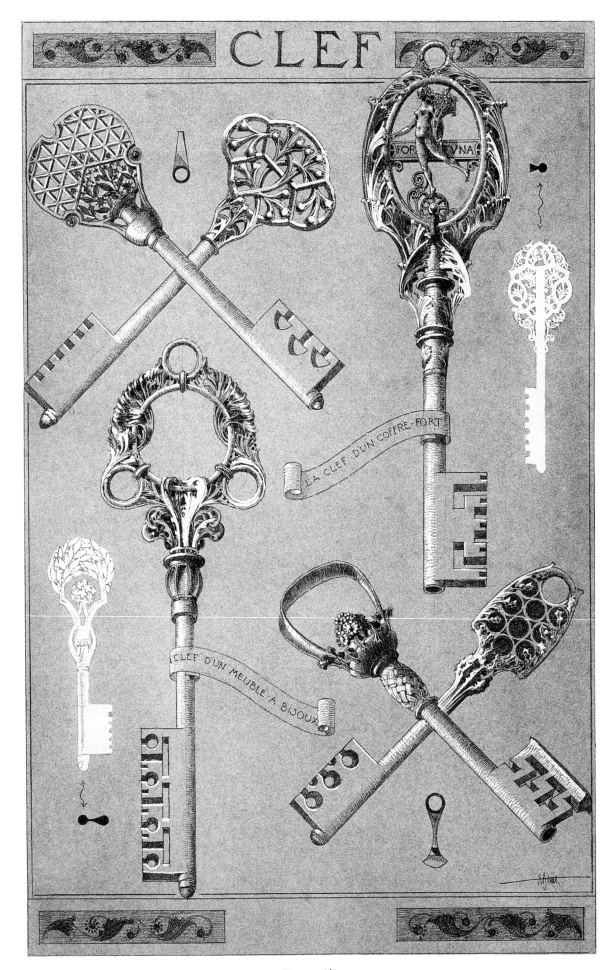

PLATE 14.

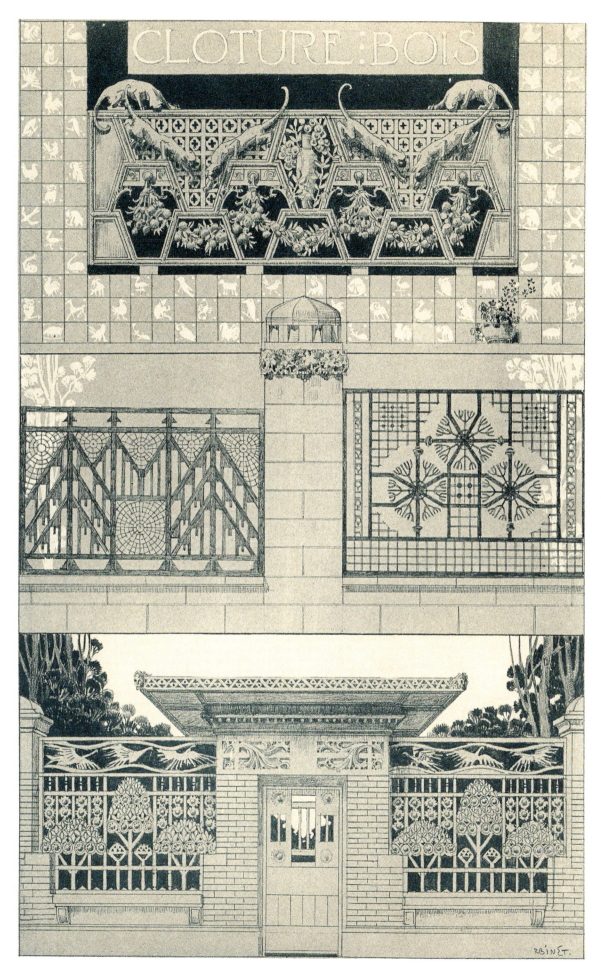

CLOTURE : BOIS

PLATE **15**.

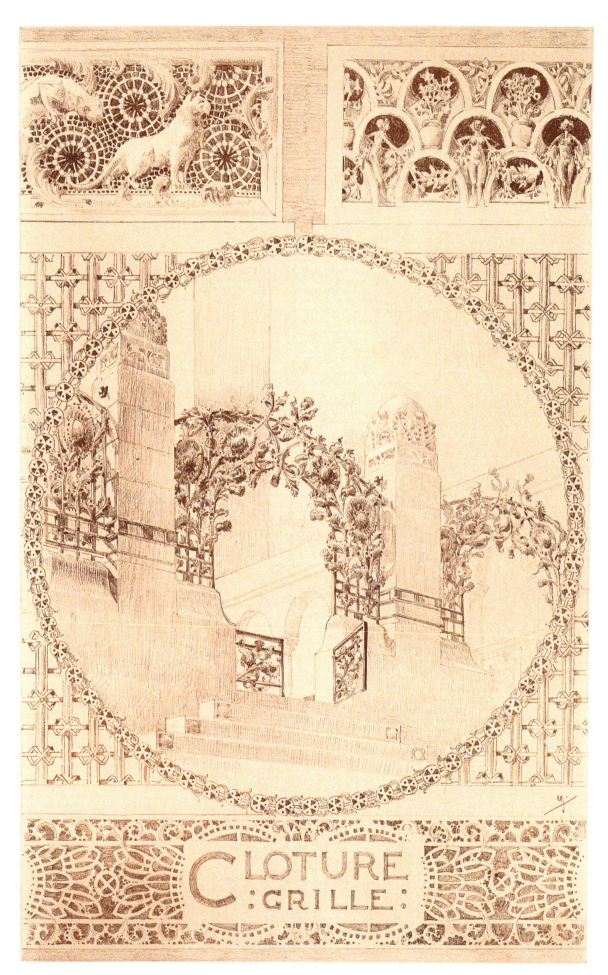

CLOTURE :GRILLE:

PLATE 16.

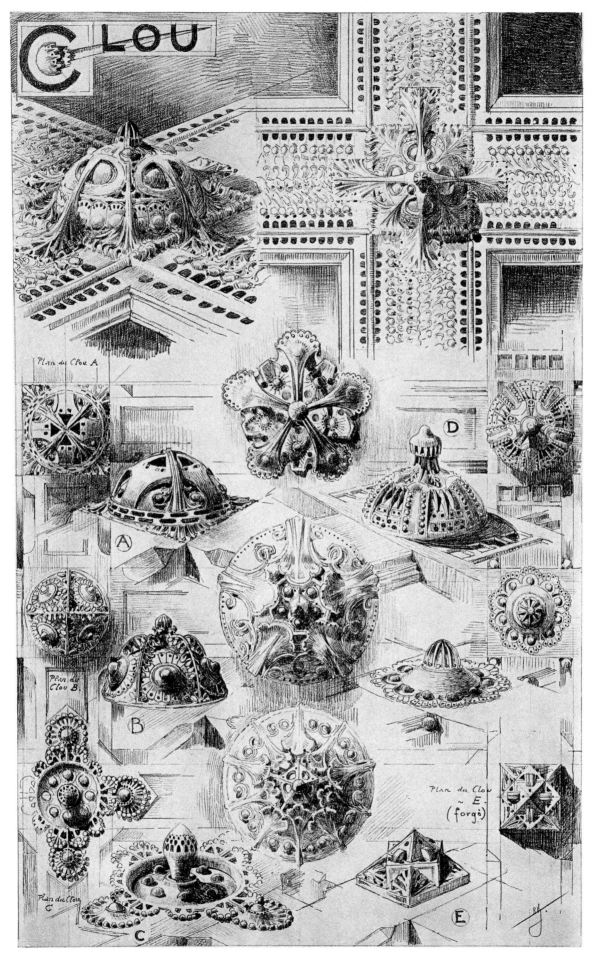

PLATE 17.

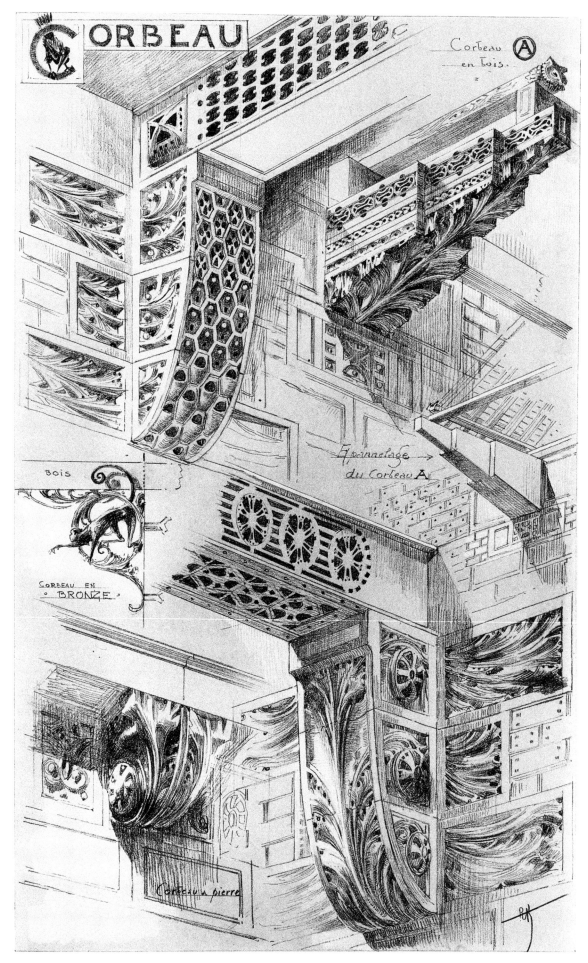

CORBEAU

Corbeau Ⓐ
en bois.

BOIS

Épannelage →
du Corbeau Ⓐ

CORBEAU EN
·BRONZE·

Corbeau en pierre

PLATE 18.

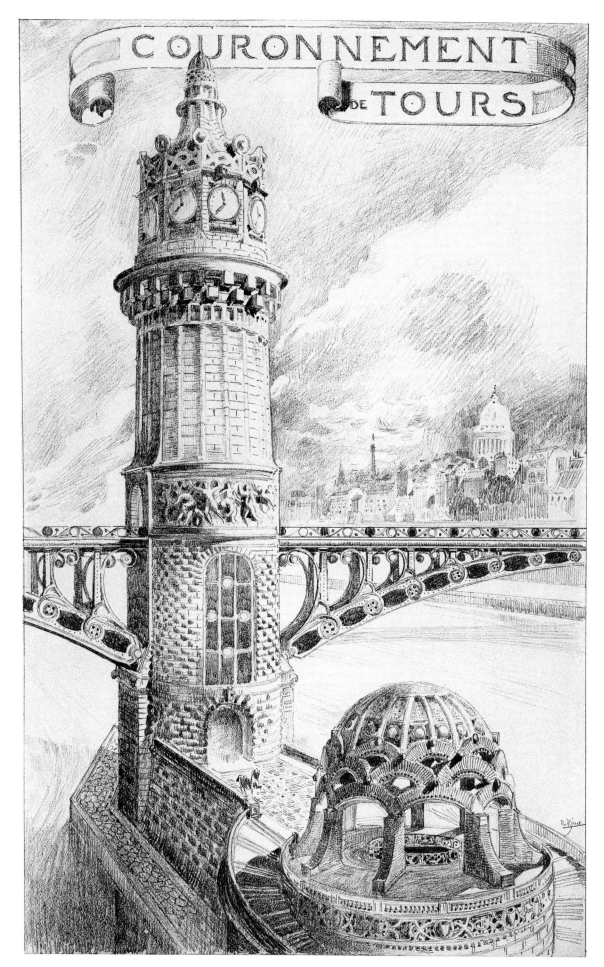

PLATE 19.

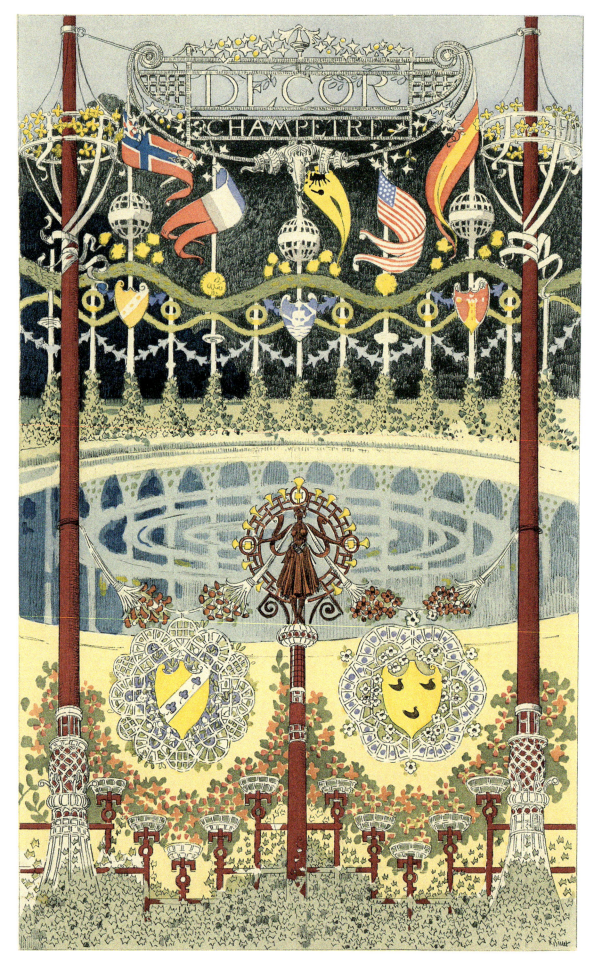

PLATE 20.

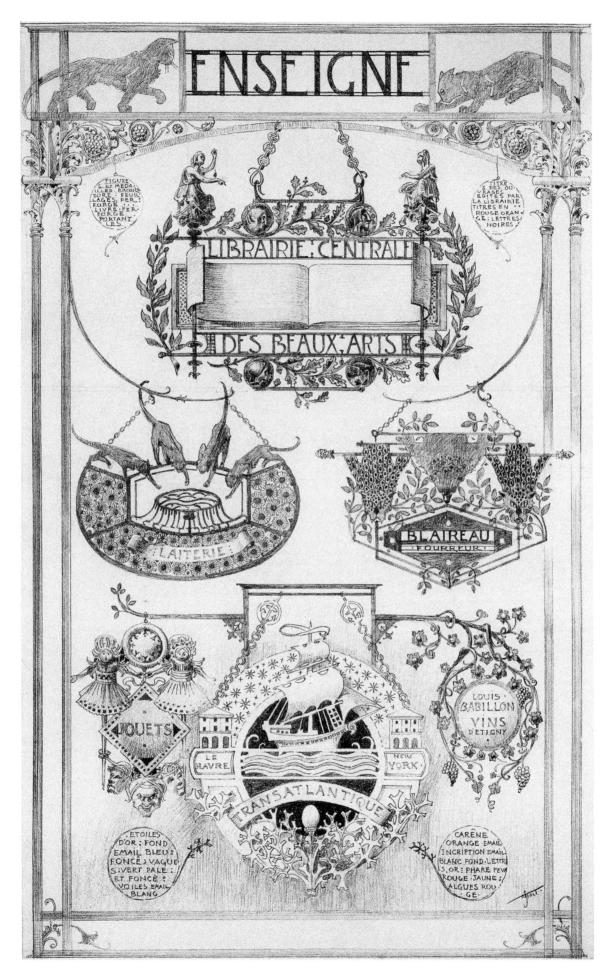

PLATE 21.

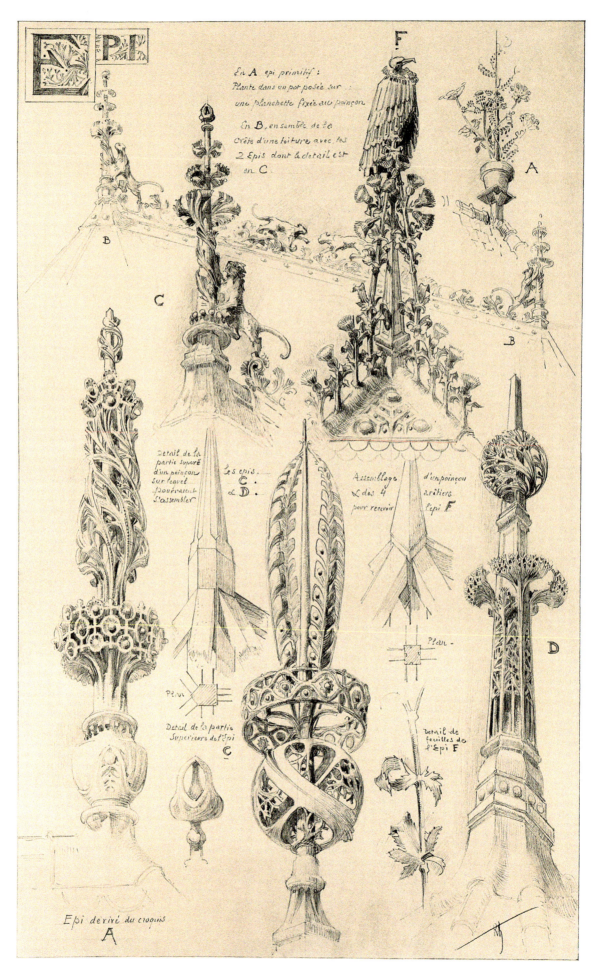

En A epi primitif:
Plante dans un pot posée sur
une planchette fixée au poinçon.

En B, ensemble de la
Crète d'une toiture avec les
2 Epis dont le detail est
en C

Detail de la
partie suporé
d'un poinçon
sur lequel
pourraient
s'assembler

les épis.
C.
& D.

Assemblage
& des 4
pour recevoir

d'un poinçon
arêtiers
l'epi F

Plan

Plan

Detail de
feuilles de
l'Epi F

Detail de la partie
Superieure de l'Epi
C

Epi derivé du croquis
A

PLATE 22.

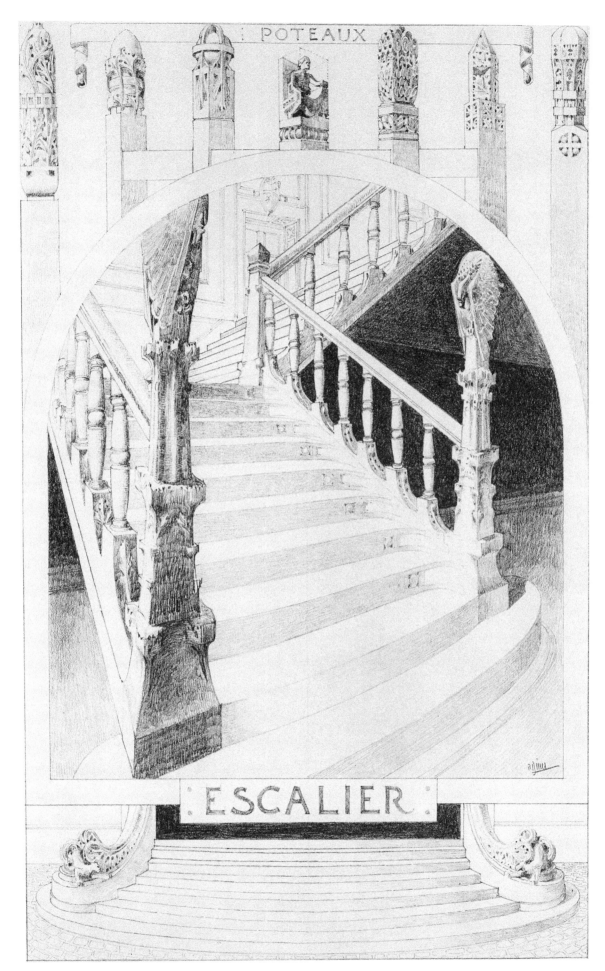

PLATE 23.

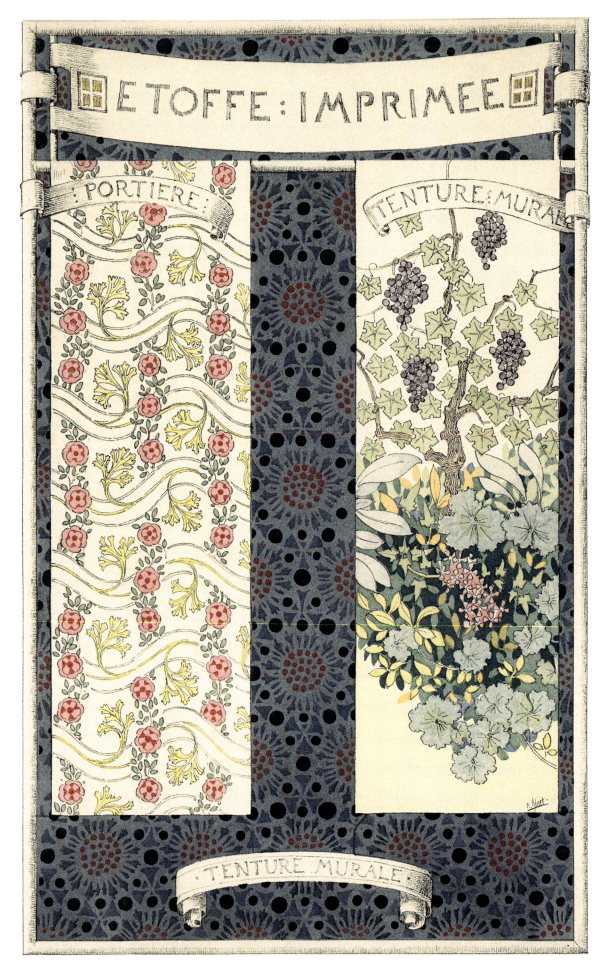

ETOFFE : IMPRIMÉE

PORTIÈRE

TENTURE : MURALE

TENTURE MURALE

PLATE 24.

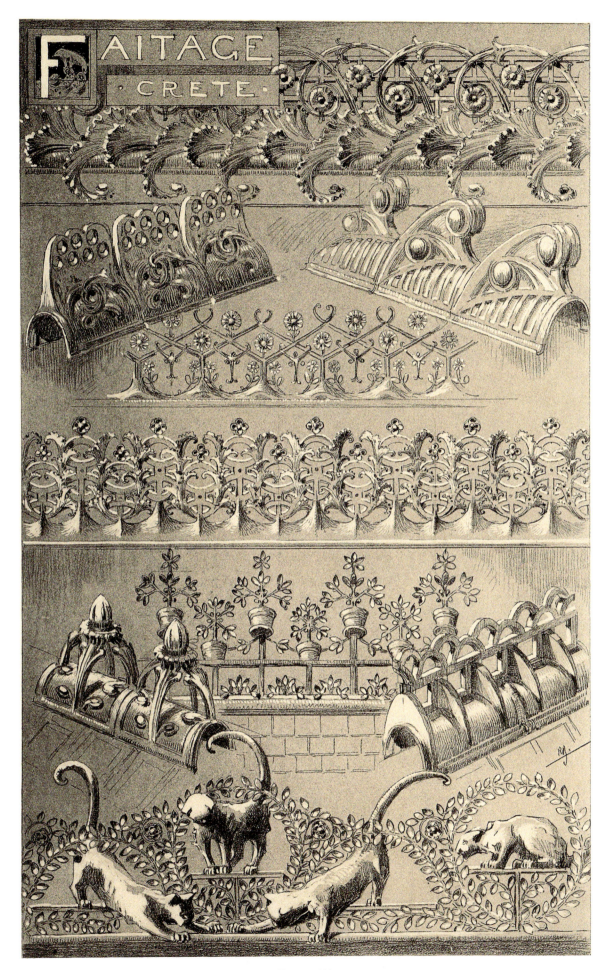

FAITAGE · CRETE ·

PLATE 25.

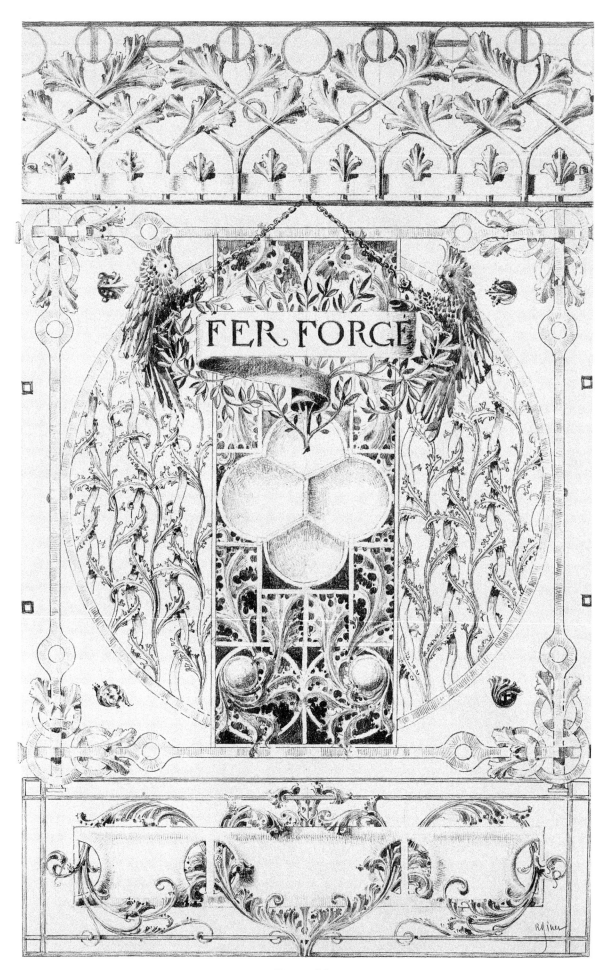

PLATE 26.

FERRONNERIE·

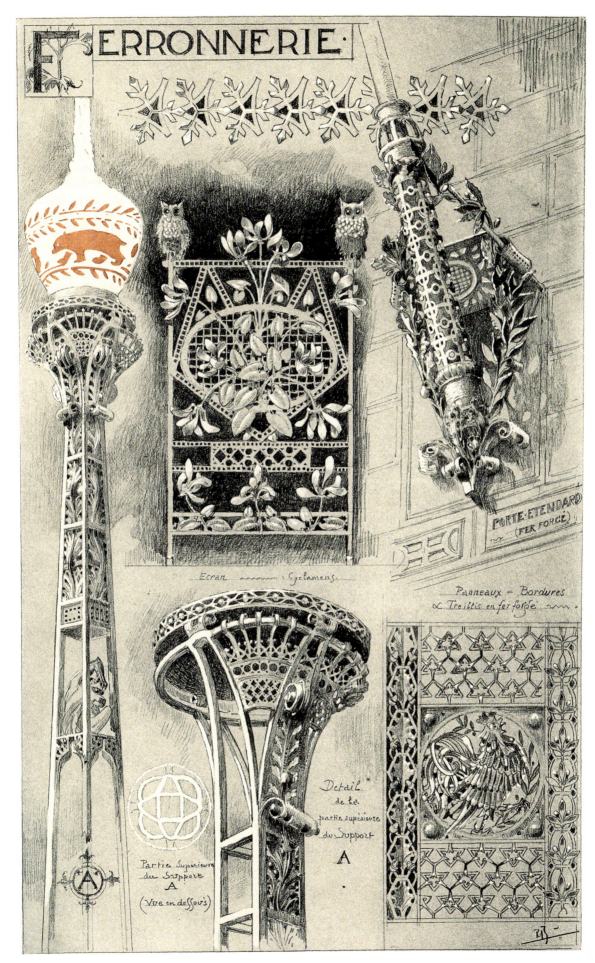

Ecran ⟶ : Cyclamens.

PORTE·ETENDARD
(FER FORGÉ)

Panneaux = Bordures
& Treillis en fer forgé

Partie Supérieure
du Support
A
(Vue en dessous)

Detail
de la
partie supérieure
du Support
A

PLATE 27.

FONTAINE

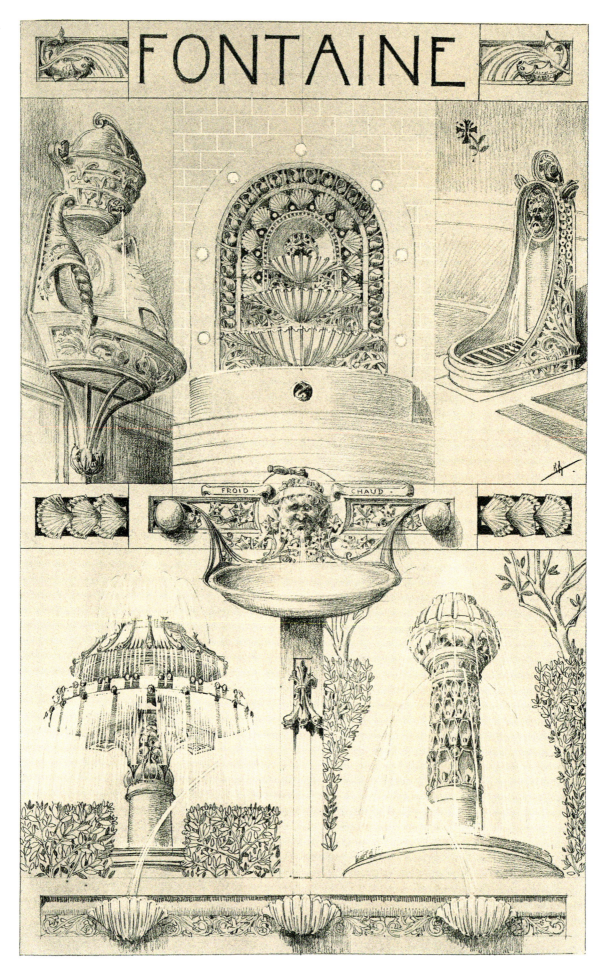

PLATE 28.

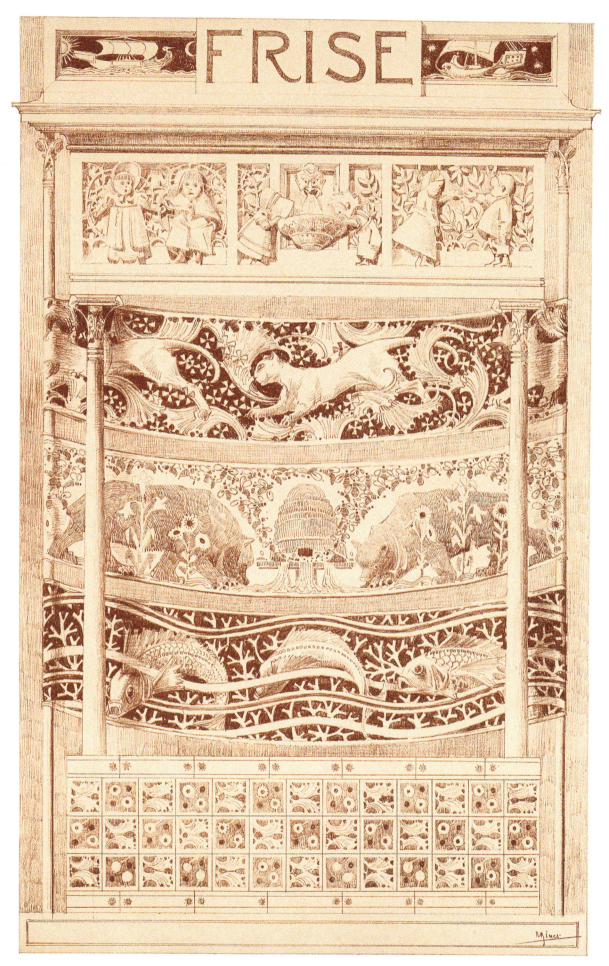

PLATE 29.

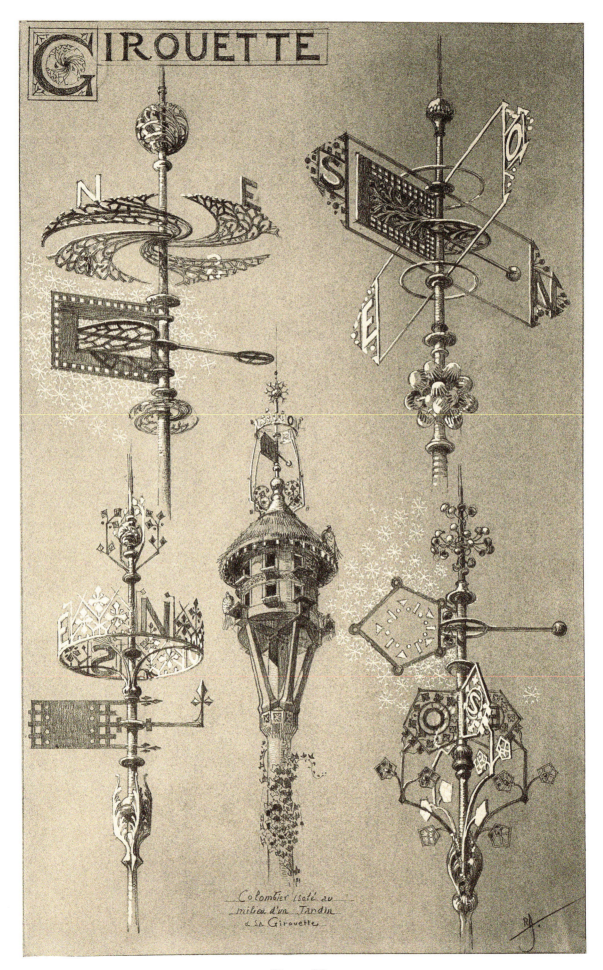

GIROUETTE

Colombier isolé au milieu d'un Jardin & sa Girouette.

Plate 30.

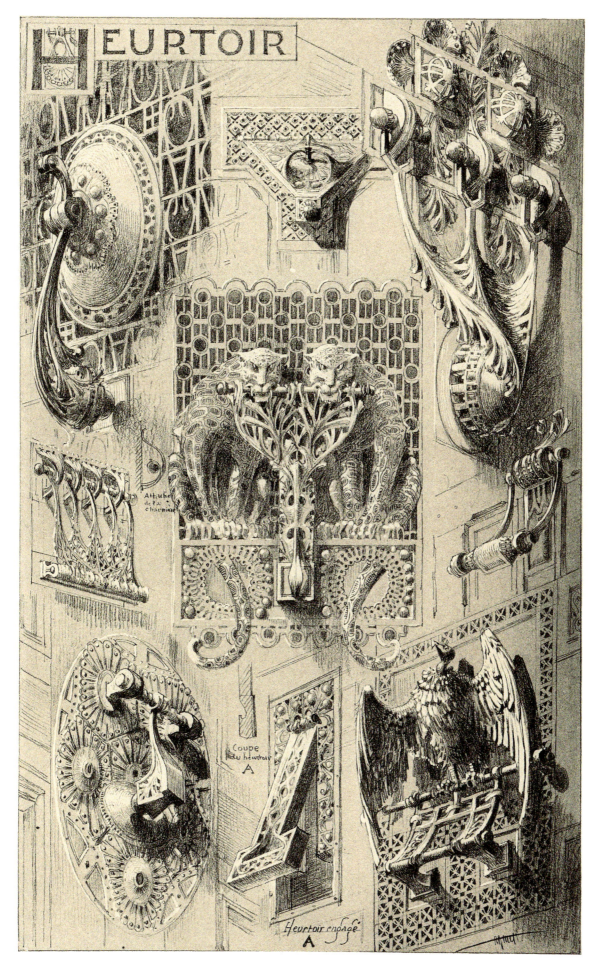

HEURTOIR

Attache
de la charnière

Coupe
du heurtoir
A

Heurtoir engagé
A

PLATE 31.

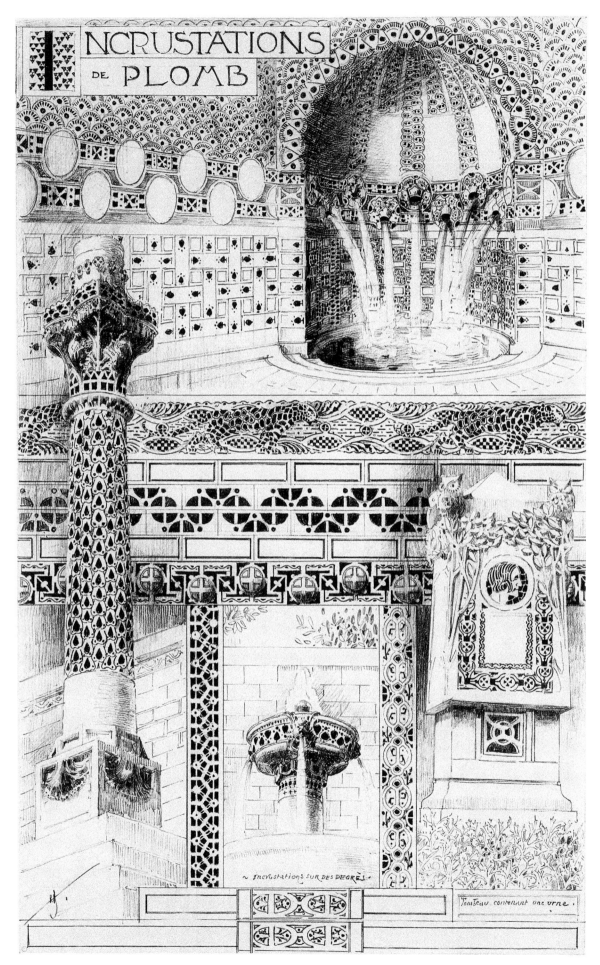

INCRUSTATIONS DE PLOMB

~ Incrustations sur des degrés ~

Tombeau contenant une urne.

PLATE 32.

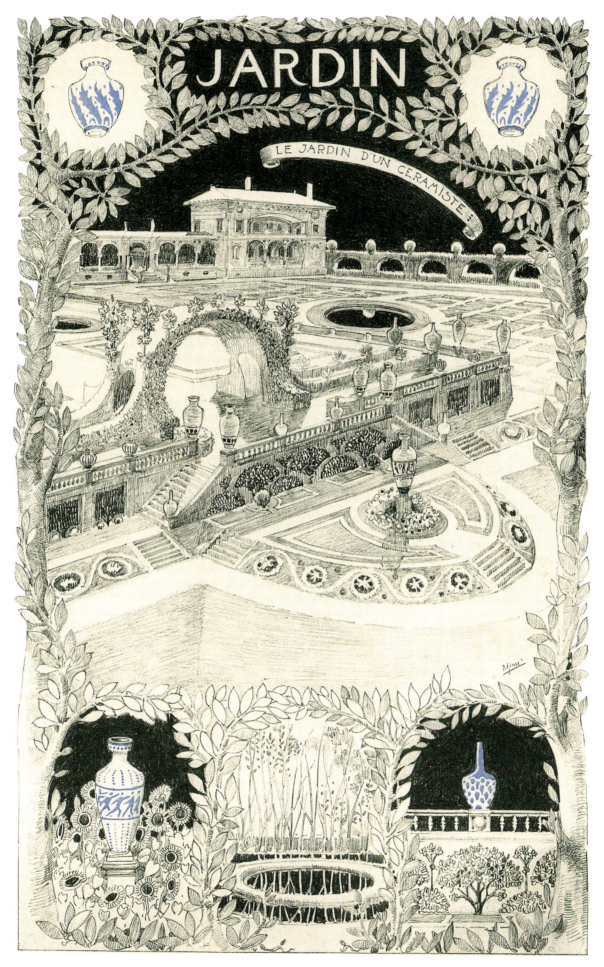

JARDIN

LE JARDIN D'UN CERAMISTE

PLATE 33.

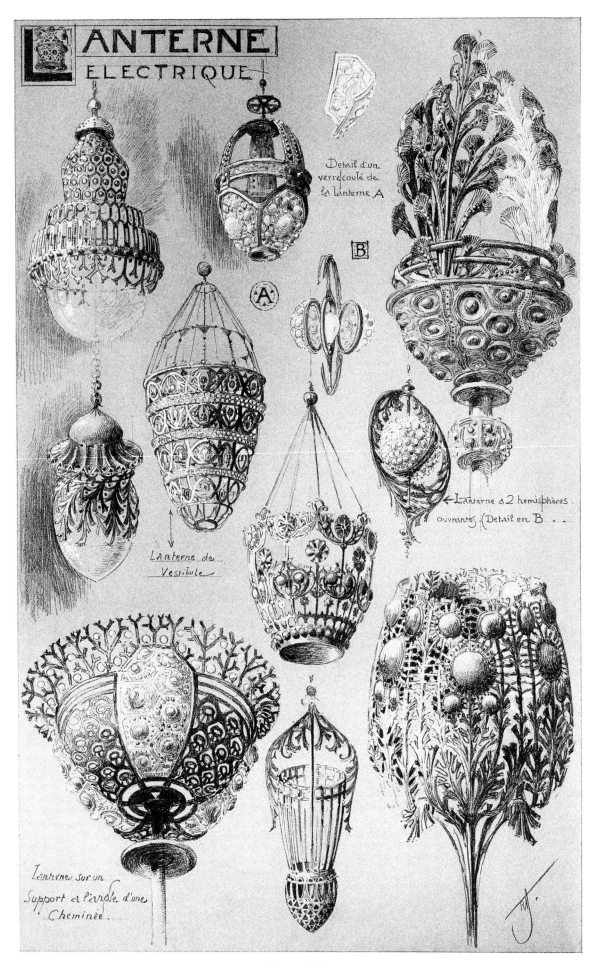

LANTERNE ELECTRIQUE

Detail d'un verre coulé de la lanterne A

B

A

Lanterne à 2 hemisphères ouvrantes (Detail en B

Lanterne de Vestibule

Lanterne sur un Support a l'angle d'une Cheminée.

PLATE 34.

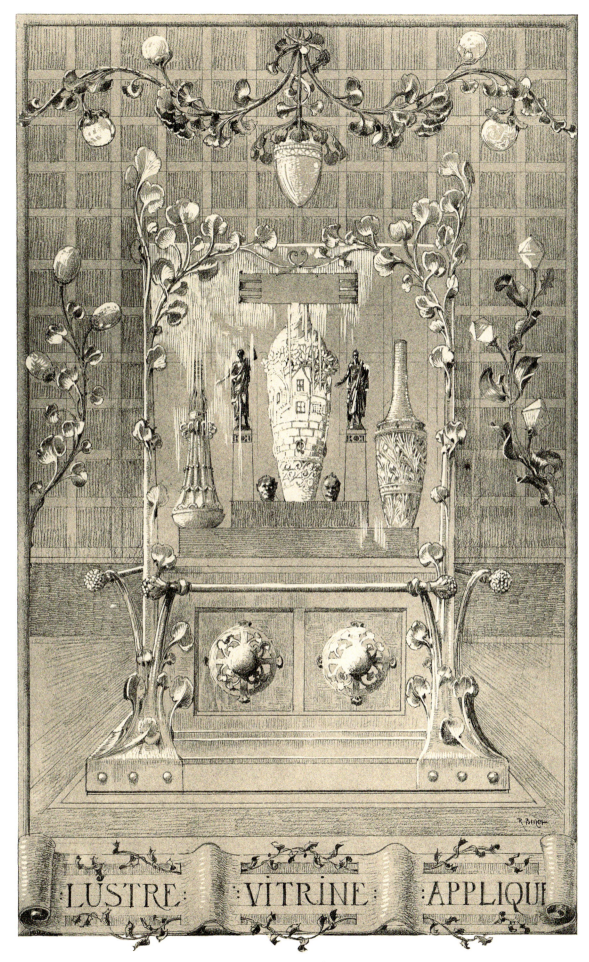

PLATE 35.

USTRE: ELECTRIQUE

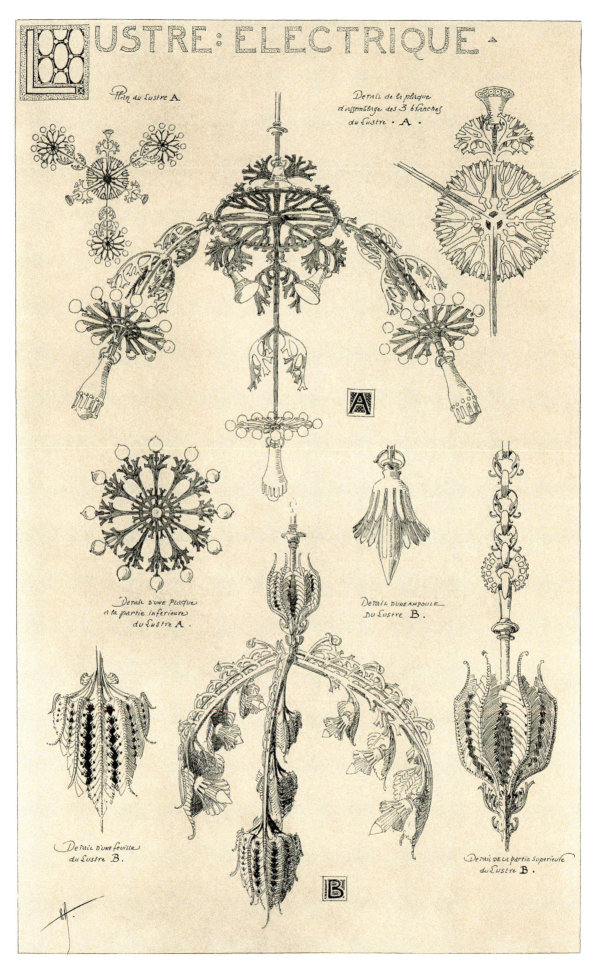

Plan du Lustre A.

Detail de la plaque
d'assemblage des 3 branches
du Lustre · A ·

A

Detail d'une plaque
à la partie inferieure
du Lustre A.

Detail d'une ampoule
du Lustre B.

Detail d'une feuille
du Lustre B.

B

Detail de la partie superieure
du Lustre B.

PLATE 36.

MAGASIN DE PARFUMEUR

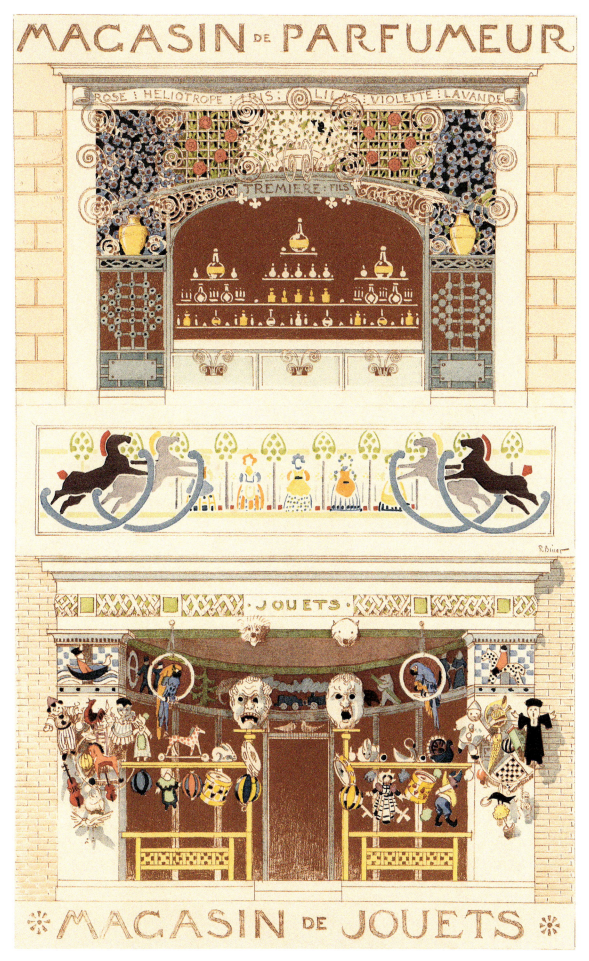

ROSE : HELIOTROPE : IRIS : LILAS : VIOLETTE : LAVANDE

PREMIERE : FILS

JOUETS

✳ MAGASIN DE JOUETS ✳

PLATE 37.

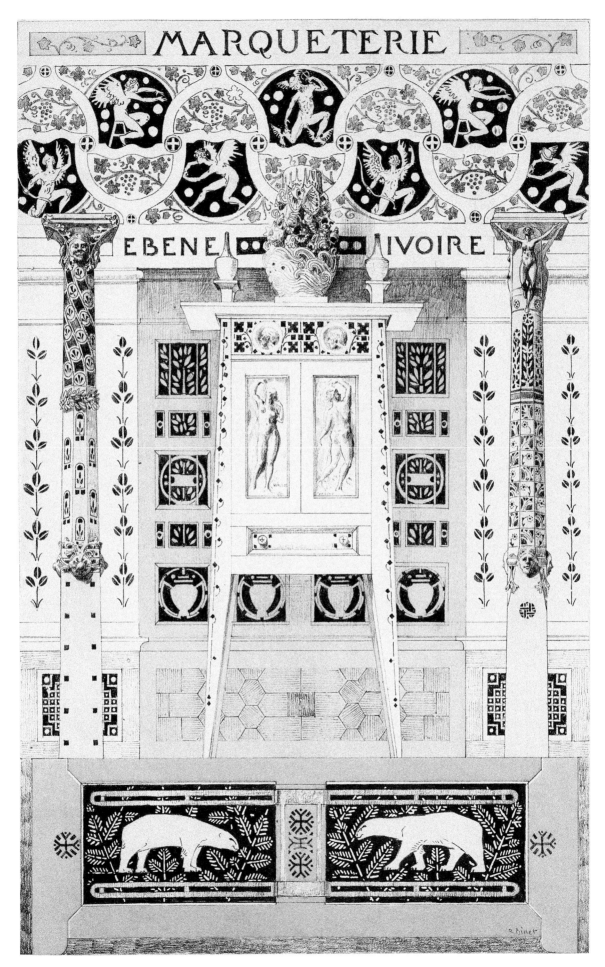

PLATE 38.

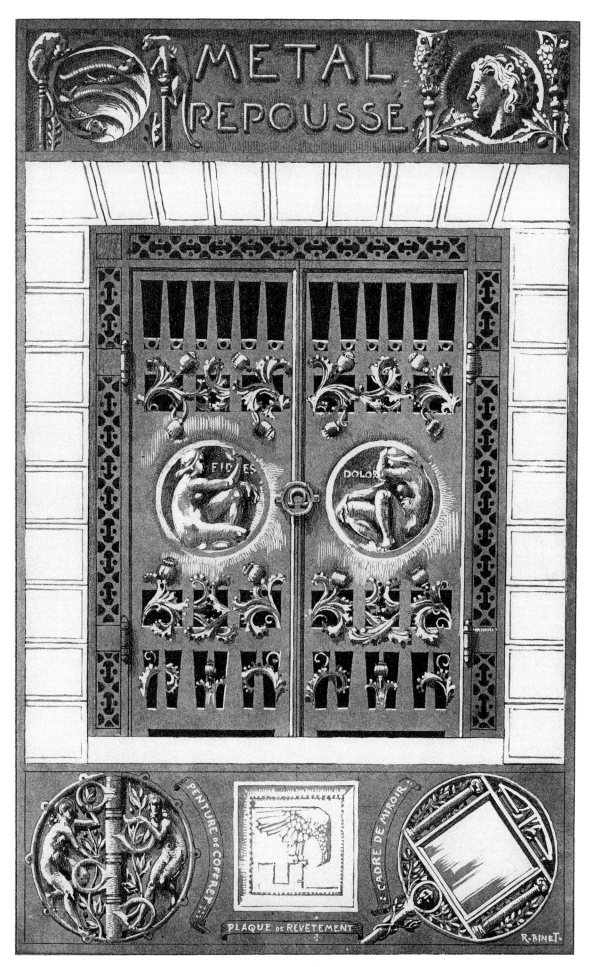

PLATE 39.

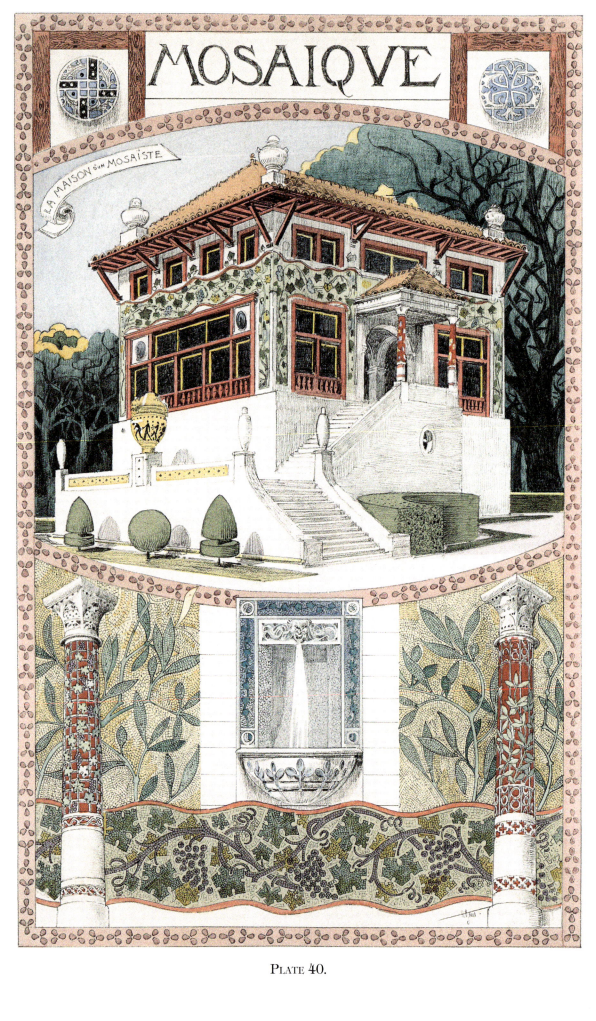

MOSAIQVE

LA MAISON D'UN MOSAÏSTE

Plate 40.

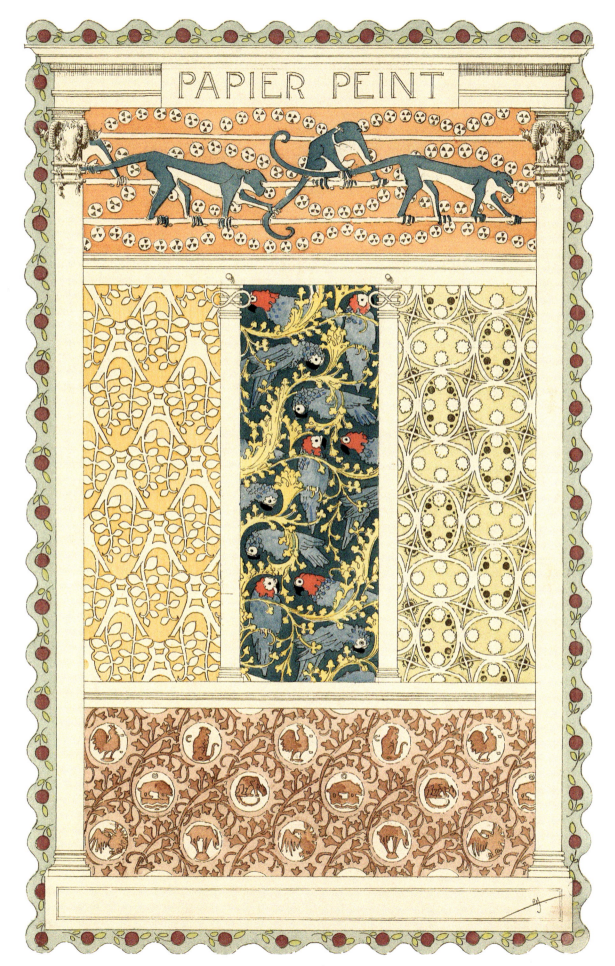

PLATE 41.

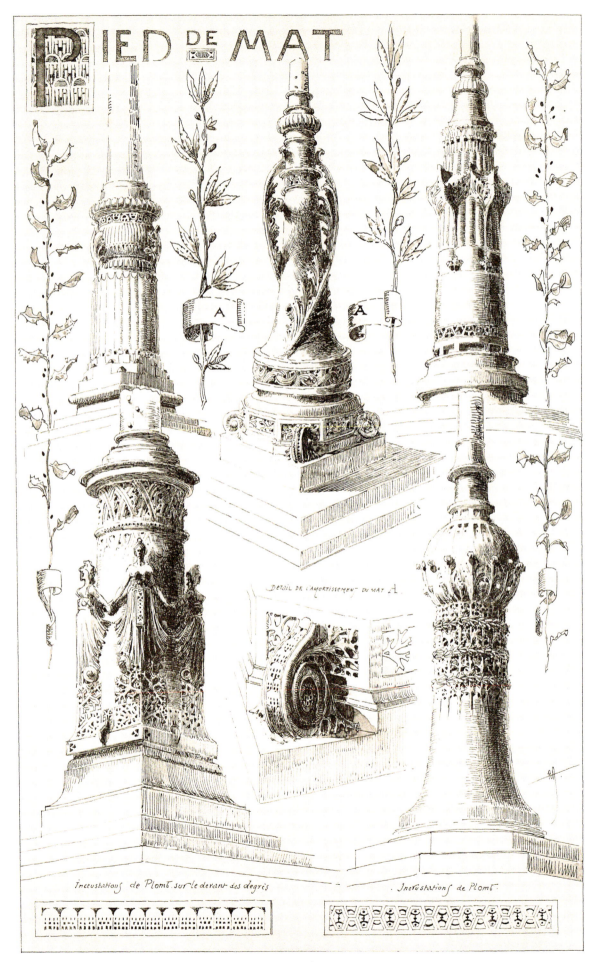

PIED DE MAT

A

A

DETAIL DE L'AMORTISSEMENT DU MAT A

Incrustations de Plomb sur le devant des degrés

Incrustations de Plomb

PLATE 42.

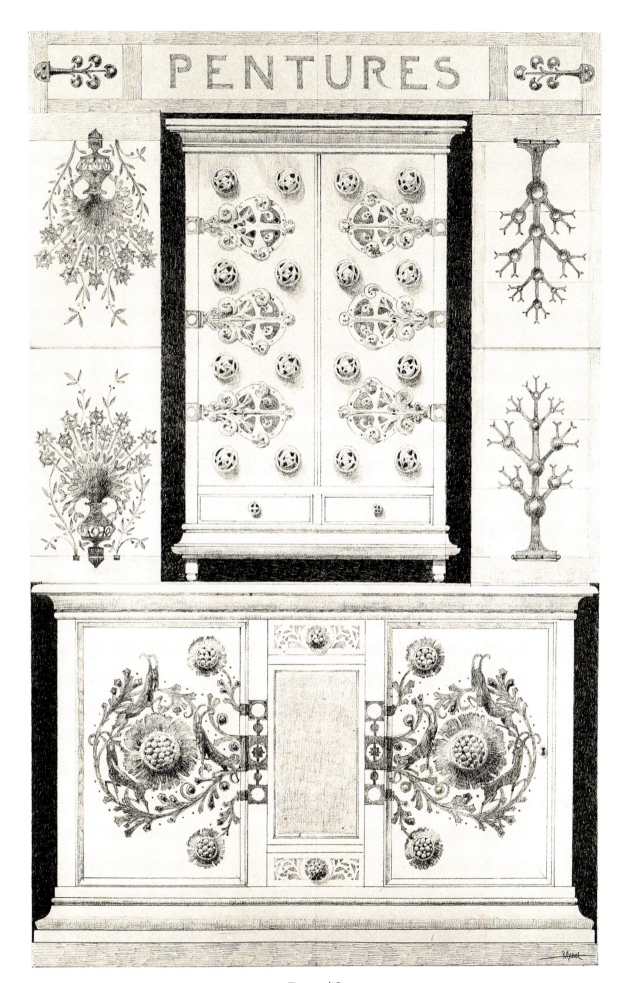

PLATE 43.

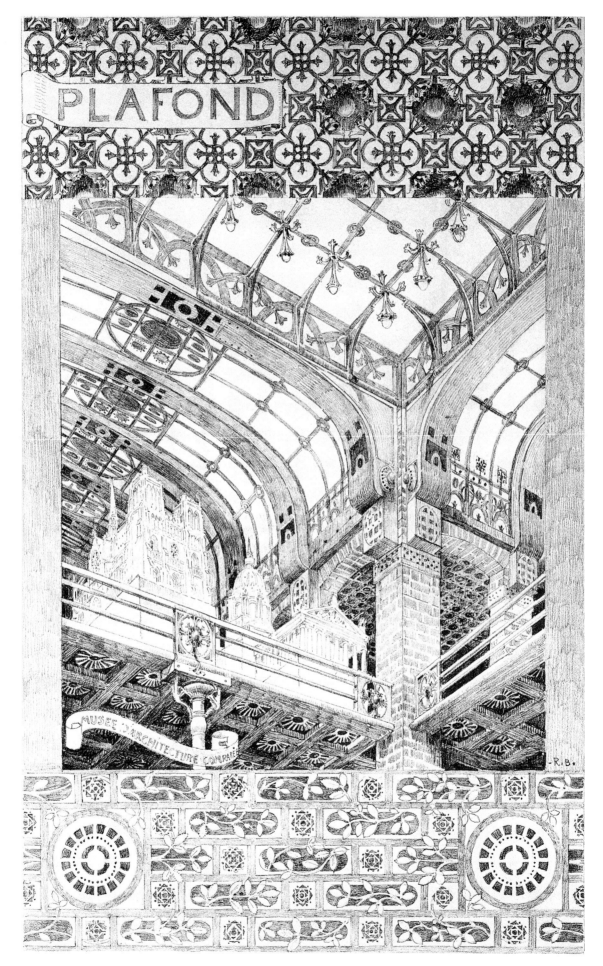

PLAFOND

MUSÉE D'ARCHITECTURE COMPARÉE

PLATE 44.

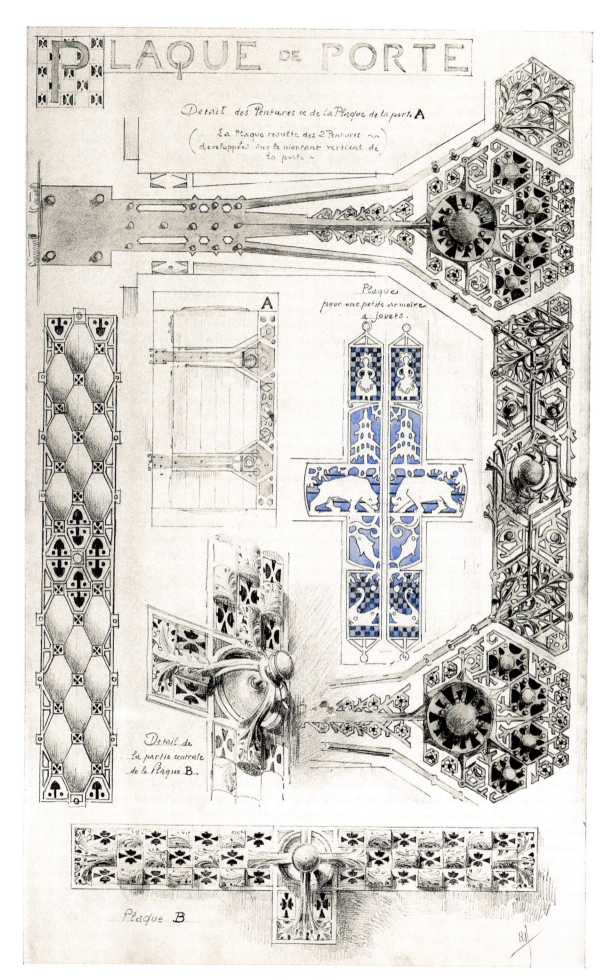

PLAQUE DE PORTE

Detail des Pentures & de la Plaque de la porte A

(La Plaque resulte des 2 Pentures)
(developpées sur le montant vertical de
la porte)

A

Plaque
pour une petite armoire
à jouets.

Detail de
la partie centrale
de la Plaque B

Plaque B

PLATE 45.

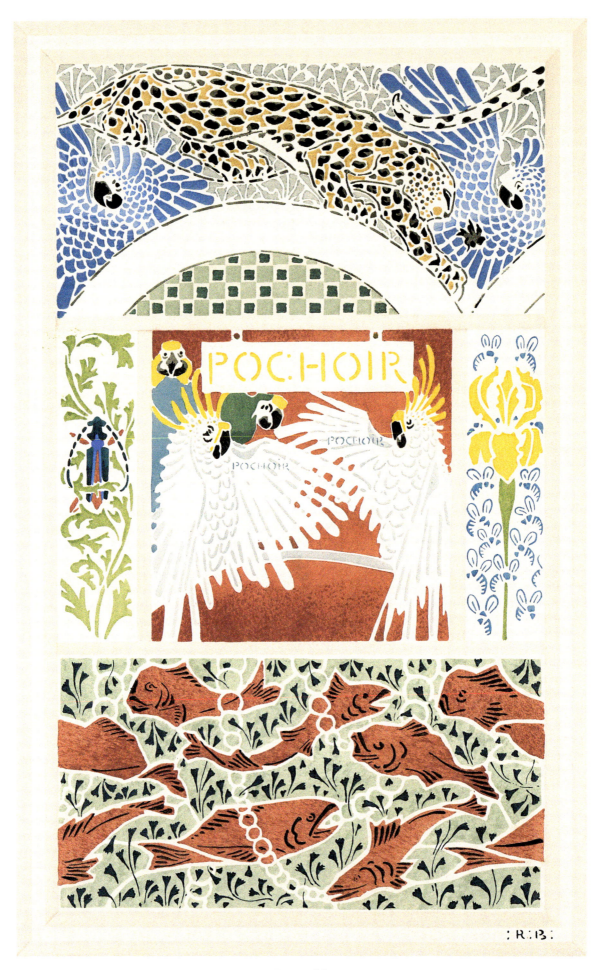

PLATE 46.

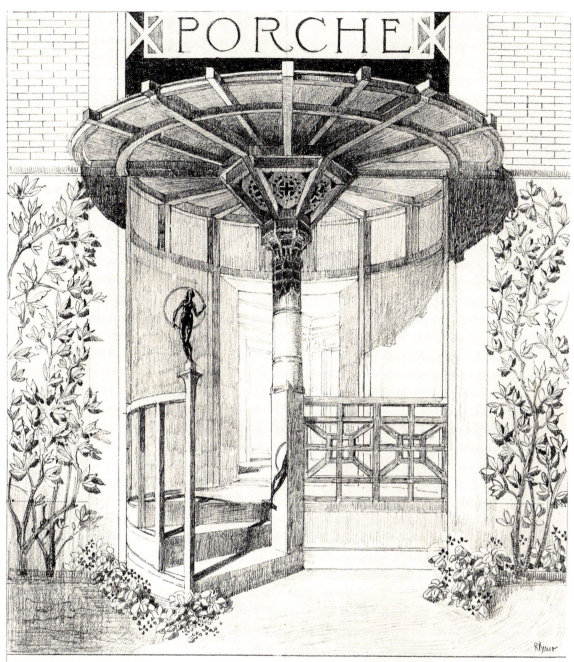

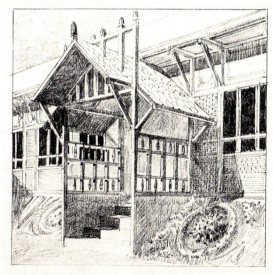

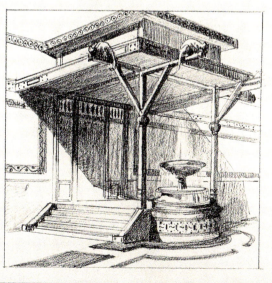

PLATE 47.

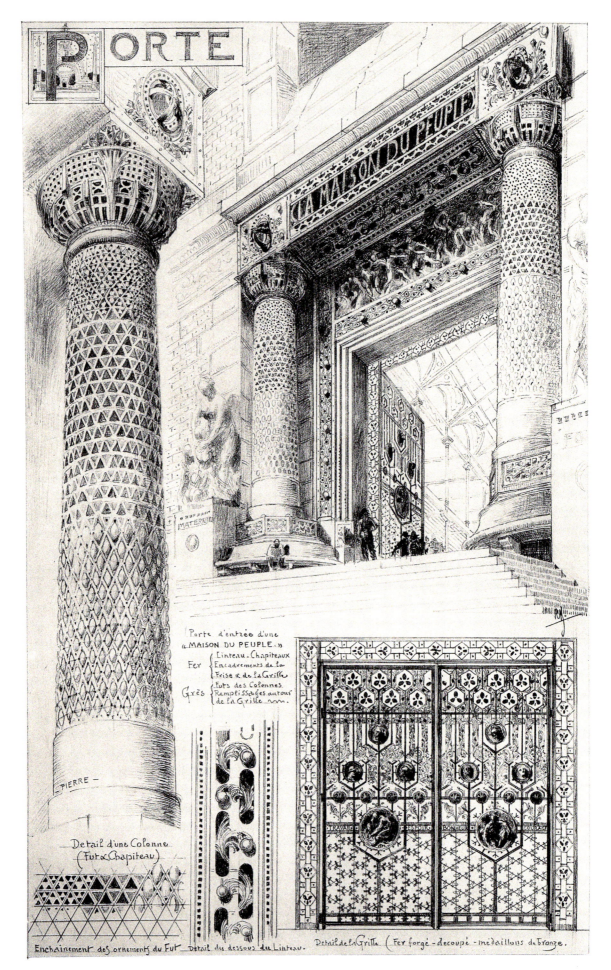

PLATE 48.

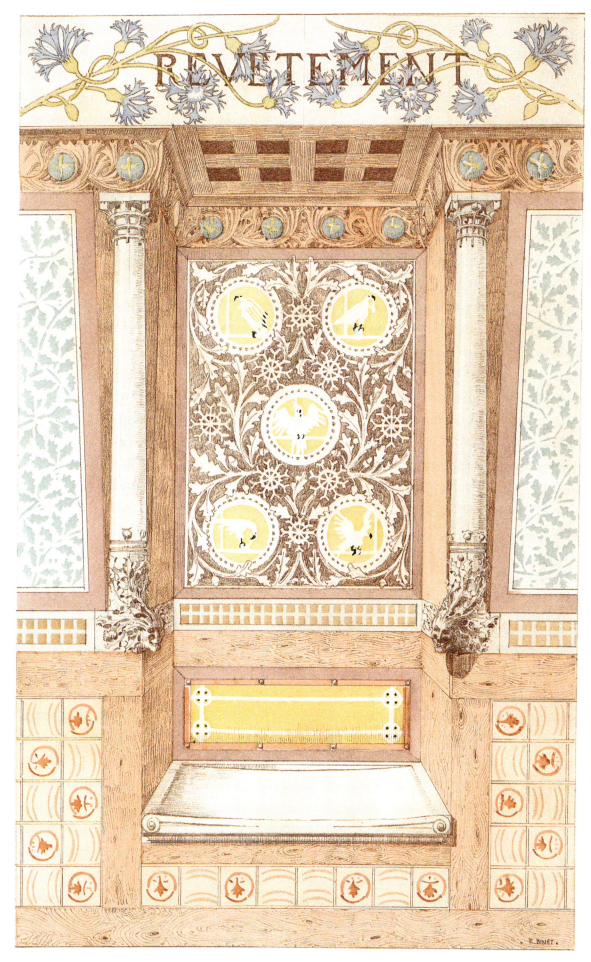

PLATE 49.

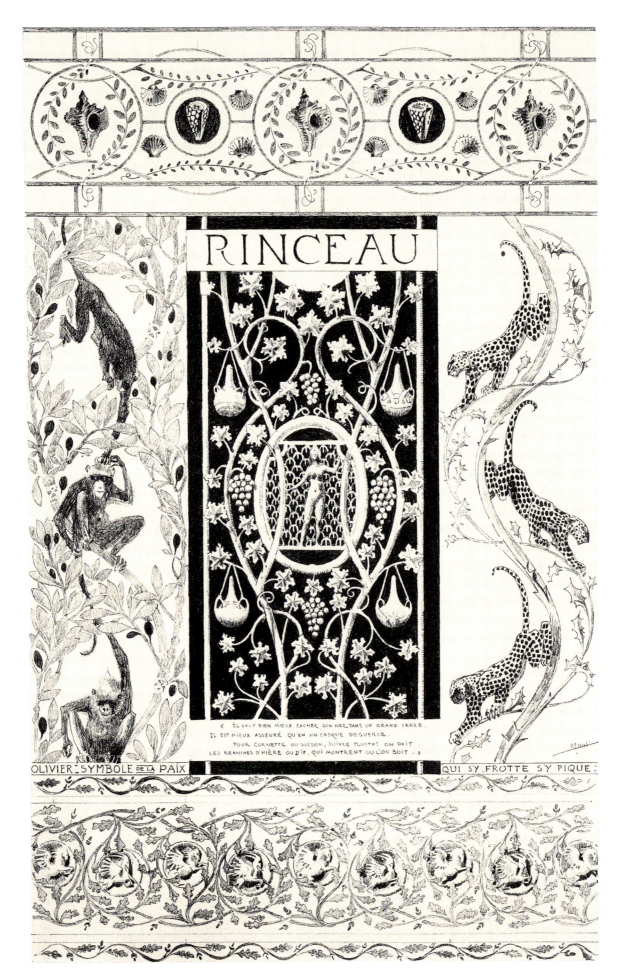

RINCEAU

« IL VAUT BIEN MIEUX CACHER SON NEZ DANS UN GRAND VERRE.
IL EST MIEUX ASSEURÉ QU'EN UN CASQUE DE GUERRE.
POUR CORNETTE OU GUIDON, SUIVRE PLUSTOT ON DOIT :
LES BRANCHES D'HIÈRE OU D'IF, QUI MONTRENT OU L'ON BOIT . »

OLIVIER . SYMBOLE DE LA PAIX

QUI S'Y FROTTE S'Y PIQUE .

PLATE 50.

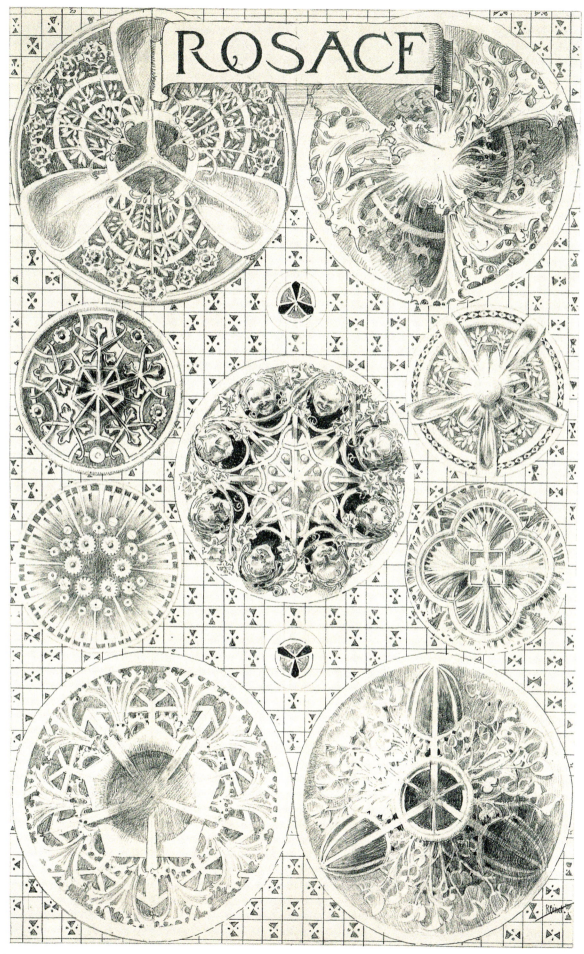

ROSACE

PLATE **51**.

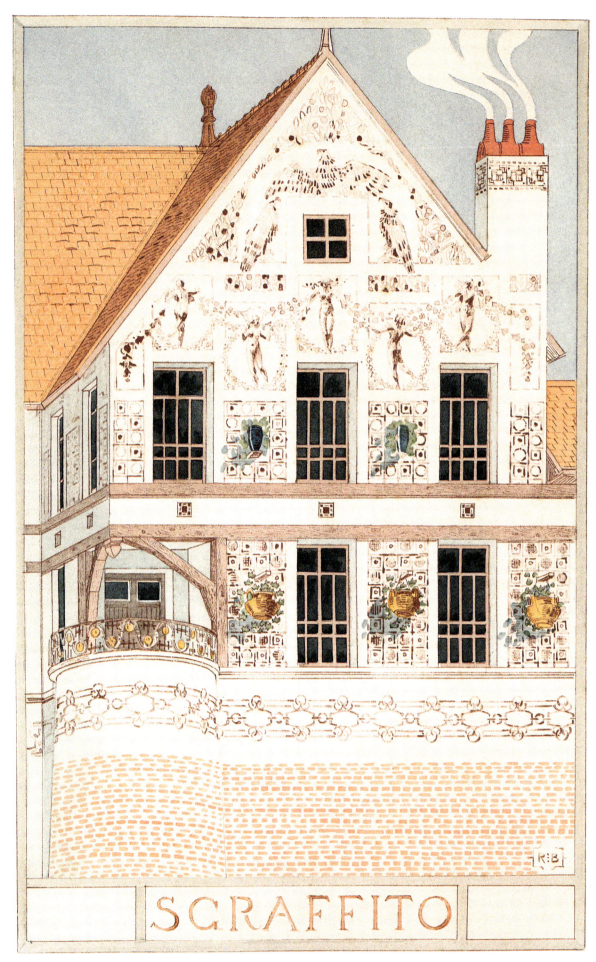

SCRAFFITO

PLATE 52.

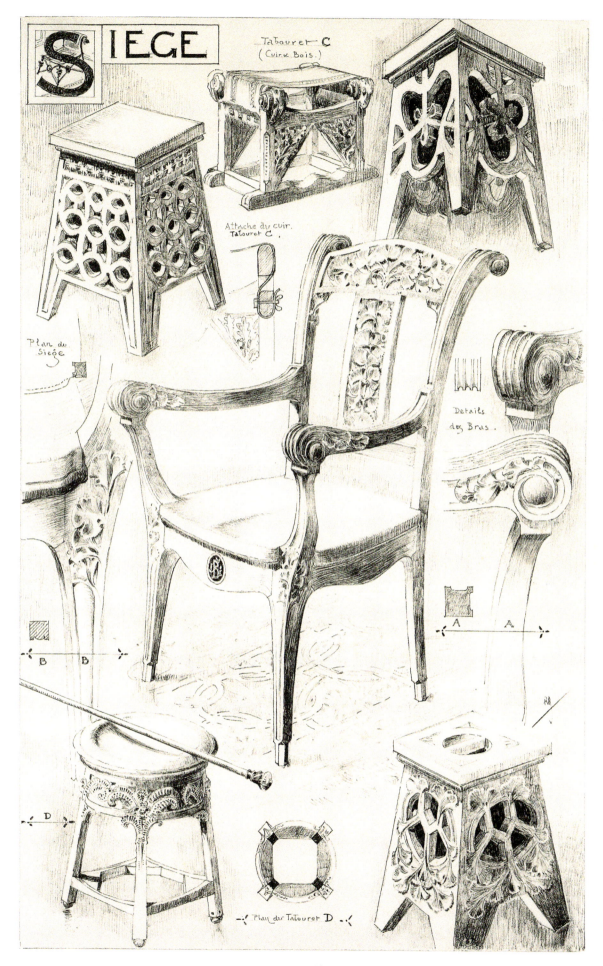

SIEGE

Tabouret C
(Cuir & Bois.)

Attache du cuir.
Tatouret C.

Plan du
Siège

Details
des Bras

A A

B B

D

Plan du Tatouret D

PLATE **53**.

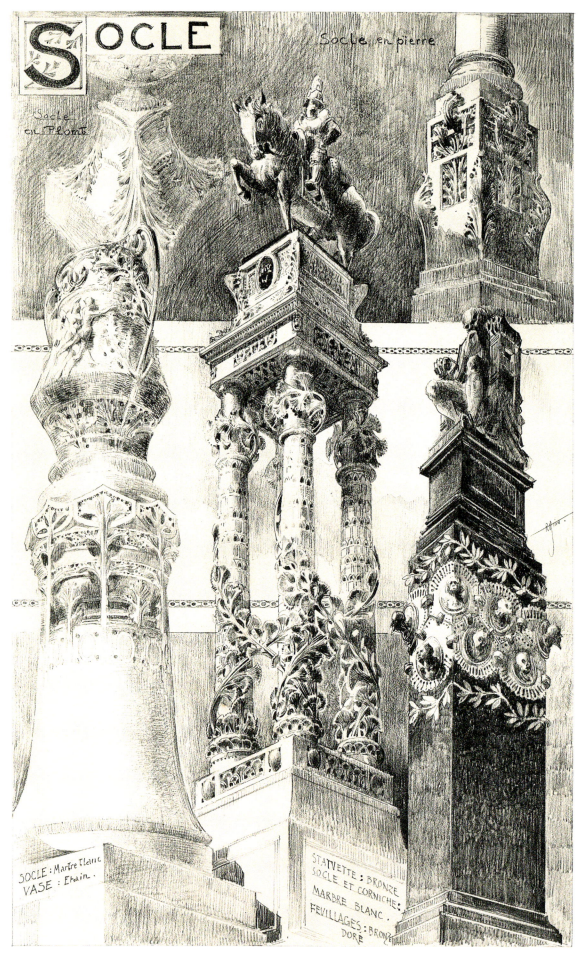

SOCLE

Socle en pierre

Socle en Plomb

SOCLE : Marbre blanc
VASE : Etain.

STATVETTE : BRONZE
SOCLE ET CORNICHE :
MARBRE BLANC
FEVILLAGES : BRONZE
DORÉ

PLATE 54.

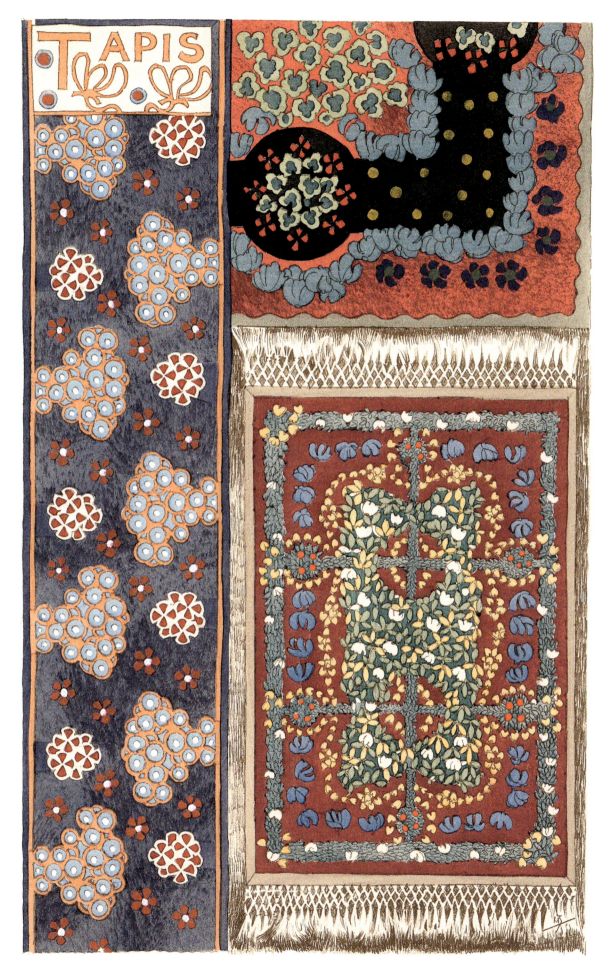

PLATE **55**.

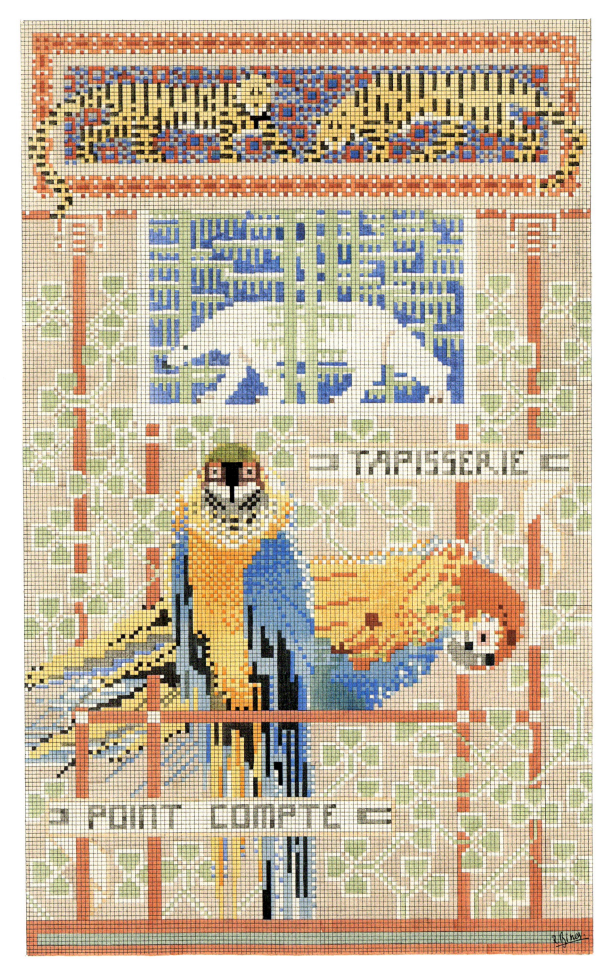

PLATE 56.

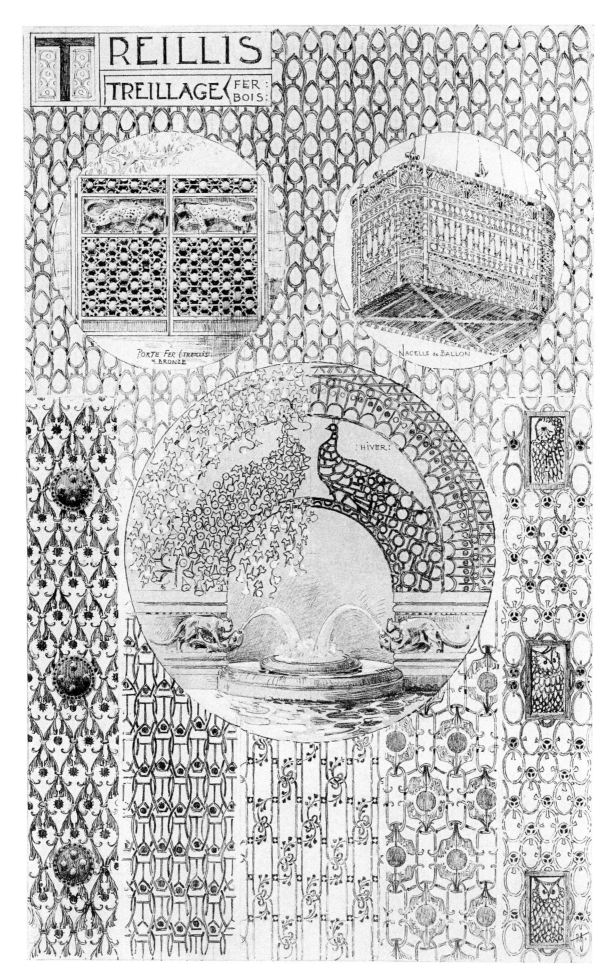

TREILLIS

TREILLAGE { FER: BOIS:

PORTE FER (TREILLIS & BRONZE

NACELLE de BALLON

:HIVER:

PLATE 57.

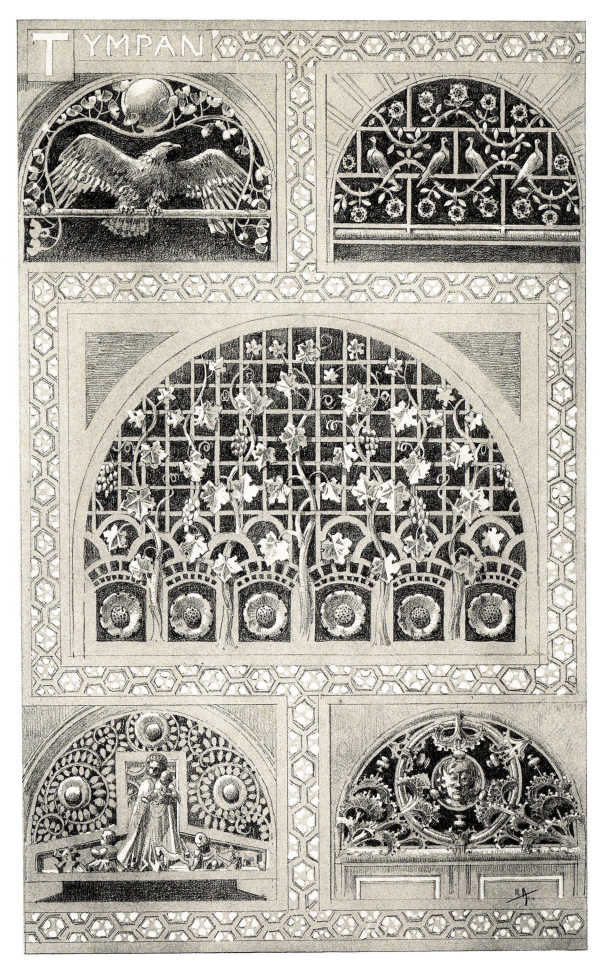

TYMPAN

PLATE 58.

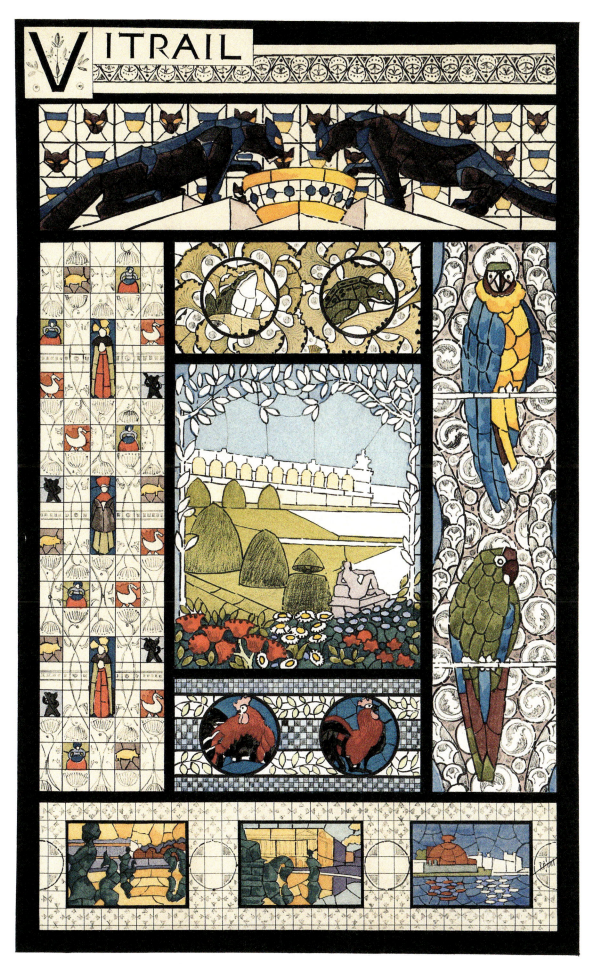

VITRAIL

PLATE 59.

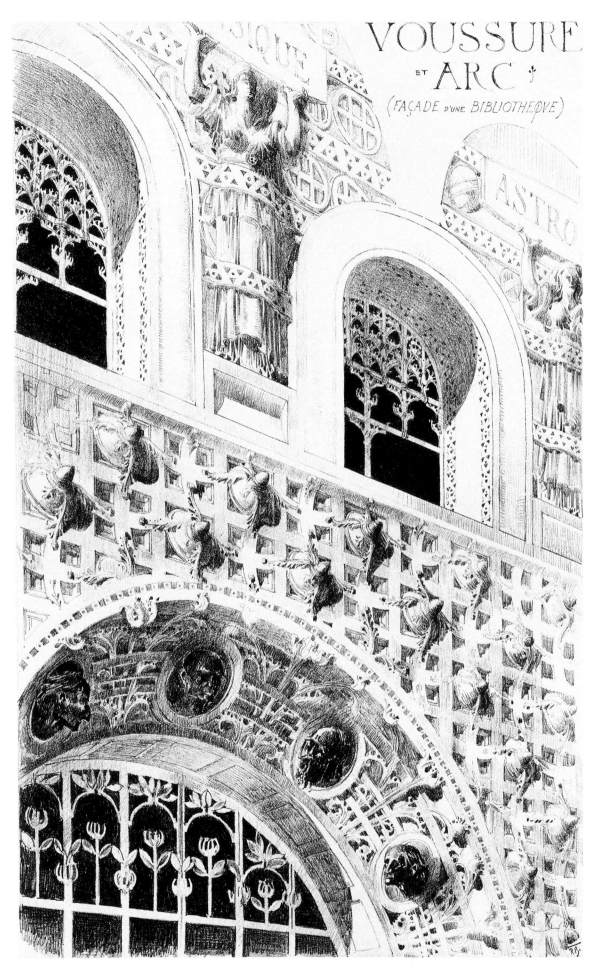

VOUSSURE
ET ARC
(FAÇADE D'UNE BIBLIOTHEQVE)

PLATE 60.